W9-DFE-901

About the Editors

Eva TALMADGE is a graduate of the University of Florida and the MFA program at Hunter College. Her fiction has appeared in *Subtropics*, *The New York Tyrant*, *The Agriculture Reader*, and *New Orleans Review*, among other publications. Her short story "The Cranes" was cited as Notable Nonrequired Reading in *Best American Nonrequired Reading 2009* (Dave Eggers, editor), and in June of 2009 she was named the first recipient of the Rona Jaffe Foundation Fellowship to fund her stay at the MacDowell Colony.

JUSTIN TAYLOR's fiction and nonfiction have been widely published in journals, magazines, and Web sites, including *The Believer*, *The Nation*, *The New York Tyrant*, the *Brooklyn Rail*, *Flaunt*, and National Public Radio. A co-editor of *The Agriculture Reader* and a contributor to HTMLGIANT.com, Taylor lives in Brooklyn. He is the author of *Everything Here Is the Best Thing Ever* and the forthcoming novel *The Gospel of Anarchy*.

THE WORD MADE FLESH

Literary Tattoos

from

Bookworms Worldwide

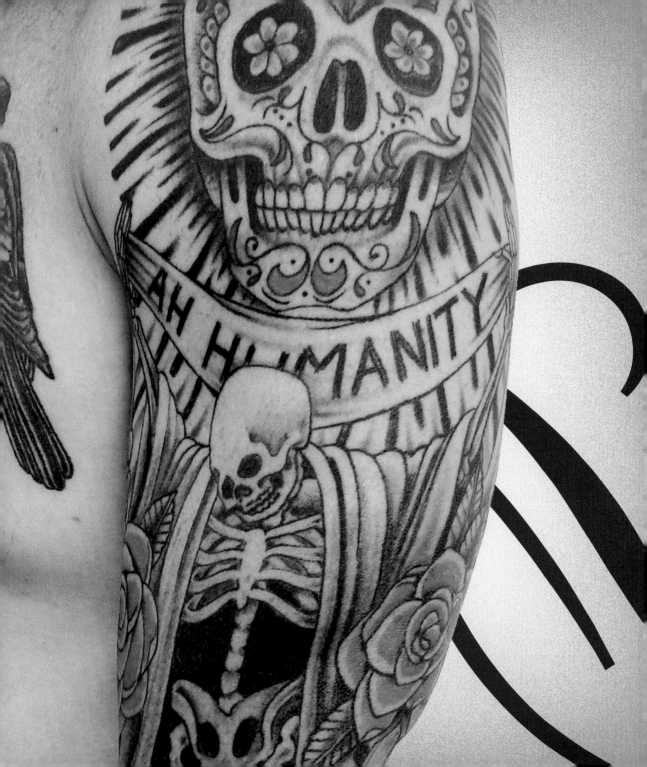

THE WORD MADE FLESH

Literary Tattoos

from

Bookworms Worldwide

EVA TALMADGE & JUSTIN TAYLOR

HARPER PERENNIAL

NEW YORK • LONDON • TORONTO • SYDNEY • NEW DELHI • AUCKLAND

HARPER PERENNIAL

HarperCollins books may be purchased for educational, business, or sales promotional use. For information please write: Special Markets Department, HarperCollins Publishers, 10 East 53rd Street, New York, NY 10022.

FIRST EDITION

Designed by Aline C. Pace

Library of Congress Cataloging-in-Publication Data is available upon request.

ISBN 978-0-06-199740-2

10 11 12 13 14 ID/RRD 10 9 8 7 6 5 4 3 2 1

"It's not the word made flesh we want in writing, in fiction, and in poetry, but the flesh made word."

—William Gass, *On Being Blue*

l(a

le
af
fa

ll

s)
one
l

iness

Introduction

When we started this project in the summer of 2009—over a meal of cheap tacos because the economy was in a nosedive and we couldn't afford much else—we had no idea how big the trend of "literary tattoos" really was. We only knew that we'd been seeing a lot of them lately: on our roommates, on writers, and even on our otherwise respectable friends—people with jobs in bookstores, publishing houses, or just plain gray carpet-covered cubes. Hardly a gang of outlaws. But we knew literary tattoos were getting popular, and not just in our little corner of Brooklyn.

According to a recent Pew Research Center survey, 36 percent of people in the United States between the ages of eighteen and twenty-five, and 40 percent between the ages of twenty-six and forty, have at least one tattoo. They're mainstream now, as acceptable as pierced ears and daring haircuts, and almost as common. So it comes as no surprise that people you might label "bookish types"—those librarians among us who know the Dewey decimal number for poetry by heart (Danielle,

page 118) or the booksellers with a love of Roberto Bolaño, Flannery O'Connor, or just birds (Paul Dean and Adam Wilson, page 124 and page 126)—would join the not-so nonconformist wave, inking a permanent declaration of love for books and writing into their very skin.

When we hatched the idea for a book of bookish tattoos, the first surprise was that it didn't exist already. The second surprise was how eager people were to be part of it. Obviously, we expected—anyway, hoped— to get some attention, but the speed, size, and energy of the response were all very happy surprises. We posted our first call for submissions to HTMLGIANT.com on July 24, 2009, about a month after conceiving the project, and the first submission (from Jenni Ripley, page 22) appeared in our in-box that same afternoon. By the end of the summer we'd been re-blogged all over the country and the world, and had enough material to make this book twice over, but we kept collecting, in search of the best of the best.

In these pages you'll find favorite lines from novels, illustrations, portraits, and passages of verse; you'll also find all kinds of testimony about the inspirations behind the tattoos: favorite books of childhood; commemorations of triumphant (or tragic) moments in lives; affirmations of friendship; drunken whims that might have (but didn't!) become cause for regret; a phrase or an image that just seemed too cool not to keep close forever. Every reason and none. You'll meet Robert Lee Emigh III (page 70) and see his tattoos inspired by Brian Evenson's novella *Dark Property*; you'll also hear from Evenson himself on the somewhat uncanny experience of encountering his own words on somebody else's arms. You'll see Katharine Barthelme's "Born Dancin'" tattoo (page 32), a tribute to her father, Donald Barthelme, one of the great writers of the twentieth century; you'll also have the chance to read the story that provided Katharine with the words, a short Barthelme gem that begins "The first thing the baby did wrong . . ." You'll learn all about

Shelley Jackson's "Skin" project (page 44). Jackson wrote a short story she is publishing, one word at a time, on the bodies of several thousand participants. Jackson's call for submissions and a wealth of statistics about the project's progress are accompanied by photos of several of her "words," including those tattooed on the novelist Rick Moody, and on Phil Campbell and Emily Hall, a married couple who have written here a fascinating essay on their decision to become part of "Skin."

The Word Made Flesh is all put together like a mix tape, one image intuitively following the next, or like a bookshelf ordered by no other system than a reader's varied taste: Louise Bogan is happily paired with Theodore Roethke, Milan Kundera follows Miguel de Cervantes, and David Foster Wallace is in good company between William Gaddis and Thomas Pynchon. Another way to think of it would be as a seating arrangement at a dinner party: William Gibson sits between Margaret Atwood and William Blake, and Ray Bradbury is surrounded by Neil Gaiman, Philip K. Dick, and Ignatz Mouse. One can only imagine the conversation between John Greenleaf Whittier and Herman Melville, or how long it would take for a food fight to start up at the kids' table, where Maurice Sendak's Wild Things meet the creations of Shel Silverstein and Eric Carle. Tattoos being, like books, quite addictive, many of our contributors boast more than one: Jack Kerouac shares one body with Chuck Palahniuk (Justin Haas, page 155), and another with Charles Bukowski (Caitlin Colford, page 157). Martin Amis appears on the same arm as W. H. Auden and Søren Kierkegaard (William Clifford, page 6). It makes for a raucous, eclectic gathering, as each contributor pays homage to a favorite writer or a beloved book (or several), and the tattoos themselves make their unchangeable declarations of selfhood, meaning, and literary association in an ever-changing world. We hope you enjoy these images as much as we have, and if you decide to join the party and get a literary tattoo of your own, we hope you'll let us know. E-mail us at tattoolit@gmailcom.

THE WORD MADE FLESH

Literary Tattoos

from

Bookworms Worldwide

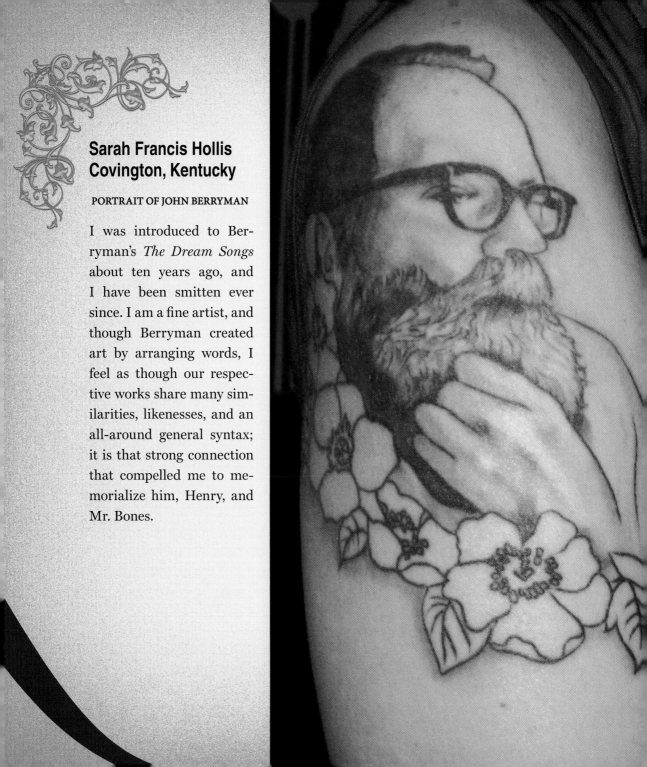

Sarah Francis Hollis
Covington, Kentucky

PORTRAIT OF JOHN BERRYMAN

I was introduced to Berryman's *The Dream Songs* about ten years ago, and I have been smitten ever since. I am a fine artist, and though Berryman created art by arranging words, I feel as though our respective works share many similarities, likenesses, and an all-around general syntax; it is that strong connection that compelled me to memorialize him, Henry, and Mr. Bones.

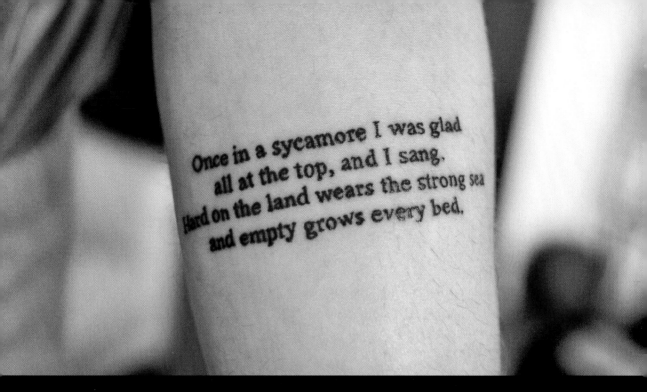

Once in a sycamore I was glad
all at the top, and I sang.
Hard on the land wears the strong sea
and empty grows every bed.

Jacob S. Knabb
Chicago, Illinois

FROM JOHN BERRYMAN'S "DREAM SONG 1"

When I got the tattoo, I wanted to preserve the "typewriter" font that houses these words in the book I have on my shelf and was able to find a tattoo artist to keep all the tiny serifs intact. This excerpt is simple and beautiful—the sounds are soft and resonant, but there is a complexity at work too. The poem ends with a succinct meditation on the intersections of youth and old age, on the nature of the world and how it wears away at everyone, until they are erased entirely, and how vividly we are able to foresee that in moments of great intensity. By capturing such a breathtaking image of beds emptied of the bones that have occupied them, these twenty-seven words resist the nostalgia that Berryman risks in ending

Noah Eli Gordon
Denver, Colorado

"POEM"

Christina Rothenbeck Westover
West Virginia

LINE FROM THEODORE ROETHKE'S "THE WALKING"

The first poetry professor I ever had in college took Theodore Roethke's refrain for his syllabus. I was nineteen years old; I had wanted to be a poet since I was sixteen, and I had traveled to the Eastern Shore of Maryland, to Salisbury, to start what turned out to be a much longer journey than I could have foreseen at the time. That first class, we discussed the ambiguity of this line—did Roethke mean he went where he had to go, and thereby learned? Or did he learn where he needed to go along the way of going? Was it the destination that was important, or the journey?

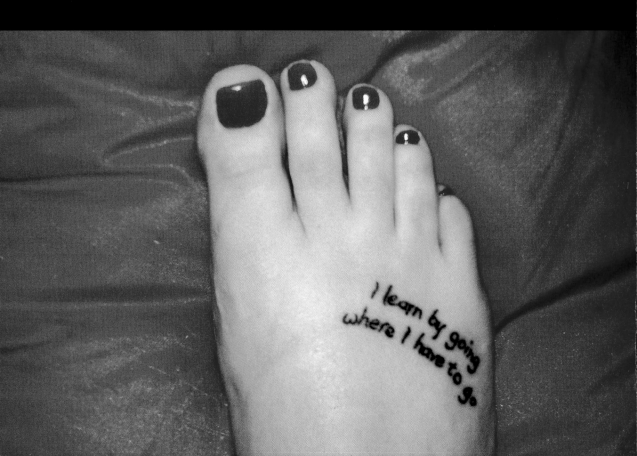

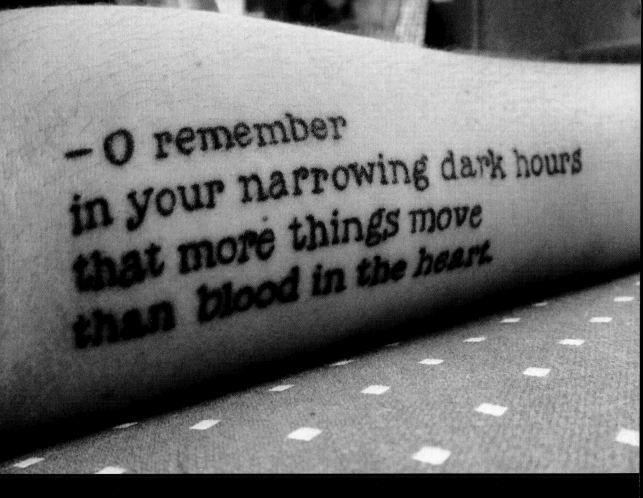

Erica Burton
Minneapolis, Minnesota

STANZA FROM LOUISE BOGAN'S "NIGHT"

William Clifford

Brooklyn, New York

Portrait of W. H. Auden

I did this tattoo to commemorate my mother, who died on the date beneath his portrait, June 17, 2003. My mother and I shared a love of literature, and I read this poem, "Leap Before You Look," at her funeral.

Last line from his own story, "Scoring"

"Scoring," published in 2000 in a book called *Pieces: A Collection of New Voices* (MTV/Pocket Books) ended with a version of this line.

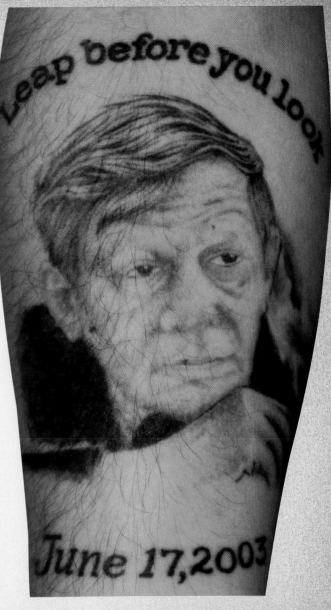

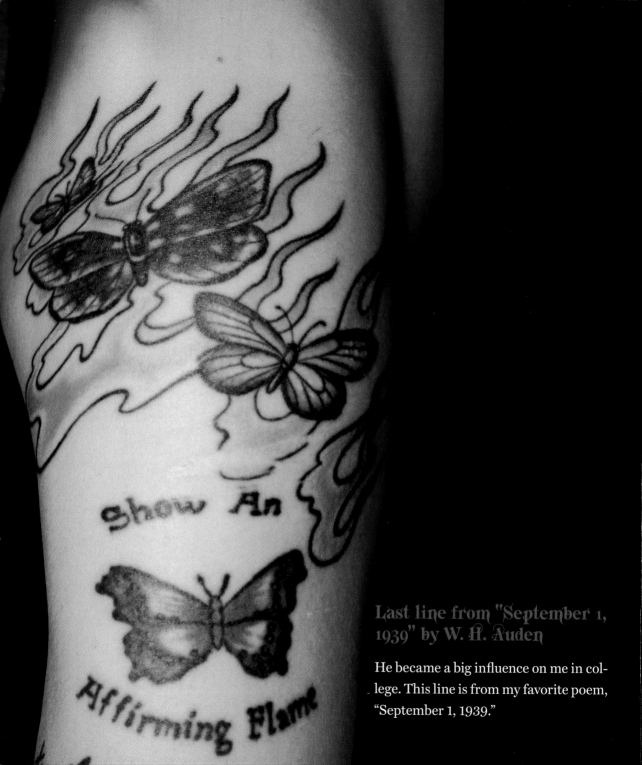

Show An

Affirming Flame

Last line from "September 1, 1939" by W. H. Auden

He became a big influence on me in college. This line is from my favorite poem, "September 1, 1939."

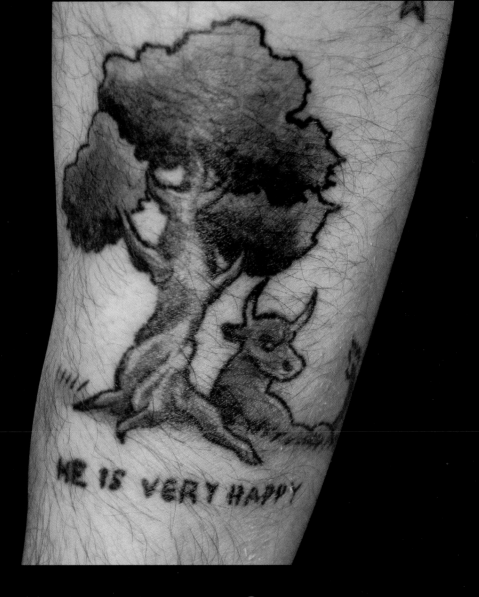

HE IS VERY HAPPY

Last line of *The Story of Ferdinand the Bull*, with illustration

The greatest children's story of all time, about the biggest bull in Spain who would rather sit quietly and smell the flowers than fight.

*I want to shiver and sob.
I look up. Something's coming.*

Sentences from *Success* by Martis Amis

My favorite living novelist is Martin Amis. When I graduated from college in 1994, I had never heard of him. One day in New York City, I went into a bookstore and saw a novel called *The Information*, the opening line of which read, "Cities, at night, I feel, contain men who cry in their sleep and then say Nothing." I loved the line and I wanted the twenty-dollar book, but only had twenty dollars on me and wanted more importantly to go to the Dublin House and have a few beers. Outside, I saw that a used book vendor had a copy of a much earlier Amis novel, the hilarious and heartbreaking *Success*, for sale for six dollars. I picked up the tattered and stained book. To the vendor I said, "I think this has blood on it"—which it did—"will you take three dollars?" He agreed and I went to the Dublin House and began my love affair with the novels of Martin Amis.

Line from Kierkegaard's *The Concept of Anxiety*

ANXIETY IS THE DIZZINESS OF FREEDOM

I want to shiver and sob
I look up

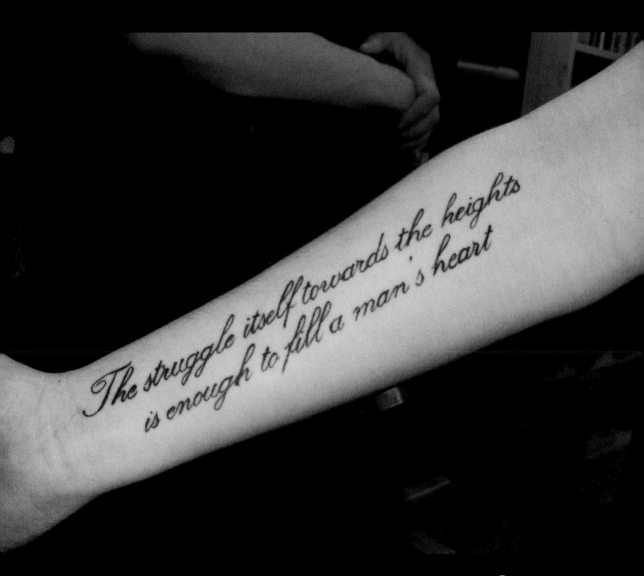

Cristina Moracho
Brooklyn, New York

LINE FROM "THE MYTH OF SISYPHUS" BY ALBERT CAMUS

The struggle itself towards the heights is enough to fill a man's heart

Tom Roberge
New York, New York

Tom Roberge
New York, New York

IMAGE FROM THE COVER OF *DREAMTIGERS* BY JORGE LUIS BORGES

Uruguayan woodcut artist Antonio Frasconi created this image for the cover of Jorge Luis Borges's *Dreamtigers* (*El Hacedor*). Discussing the desire to control his dreams and "cause a tiger," he concludes: "Never can my dreams engender the wild beast I long for. The tiger indeed appears, but stuffed or flimsy, or with impure variations of shape, or of an implausible size, or all too fleeting, or with the touch of the dog or the bird."

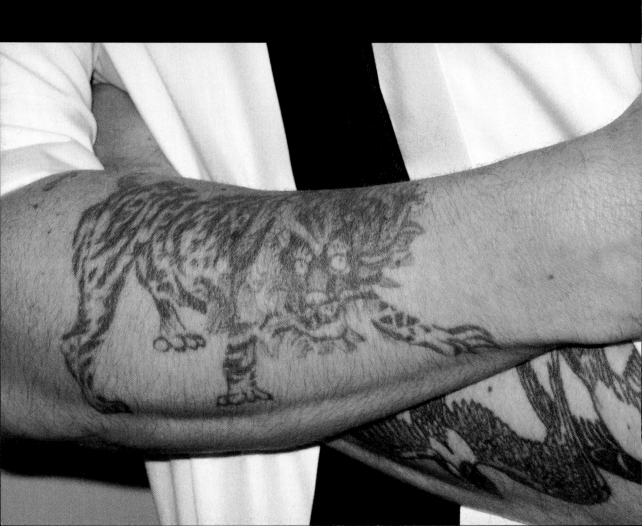

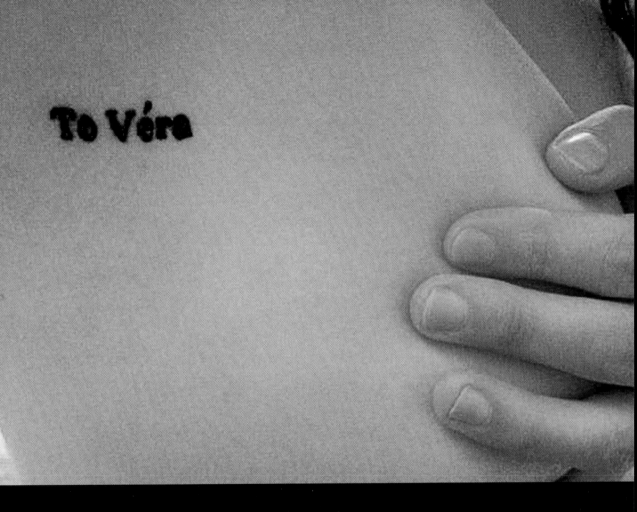

Kourtney Paranteau
Portland, Orego

"TO VERA"—NABOKOV'S DEDICATION OF HIS BOOKS TO HIS WIFE

Kristina Grinovich

Boston, Massachusetts

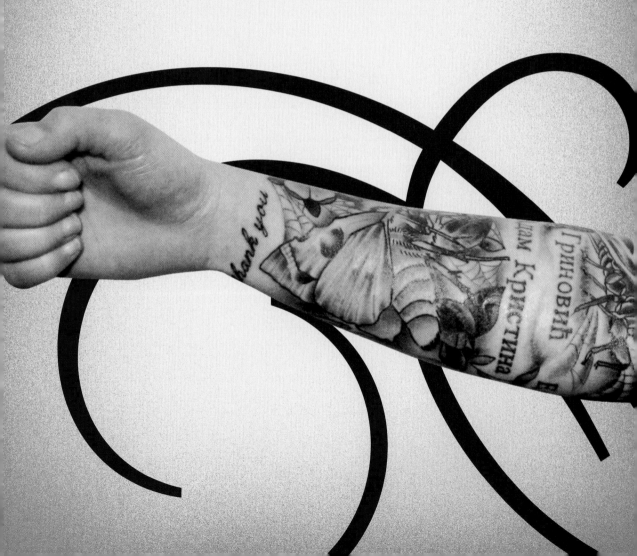

My father gave me a book of short stories by Franz Kafka when I was in middle school. I became immediately obsessed with Kafka and read everything of his that I could get my hands on. Since those first years spent devouring Kafka's stories, novels, aphorisms, and journals, I have devoted my time to writing, reading, and studying literary works. What began as a simple gift from my father became a life as a writer and artist.

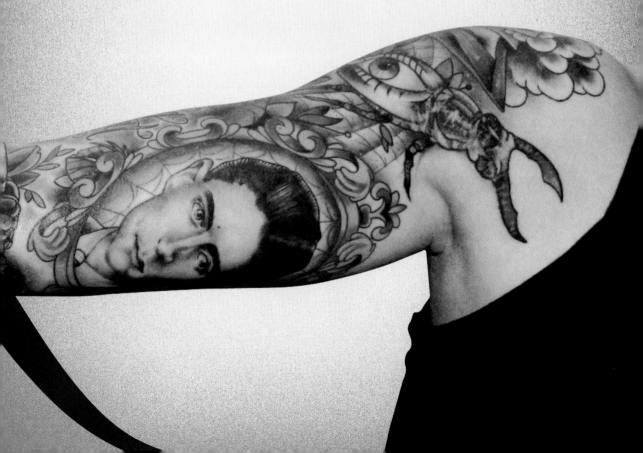

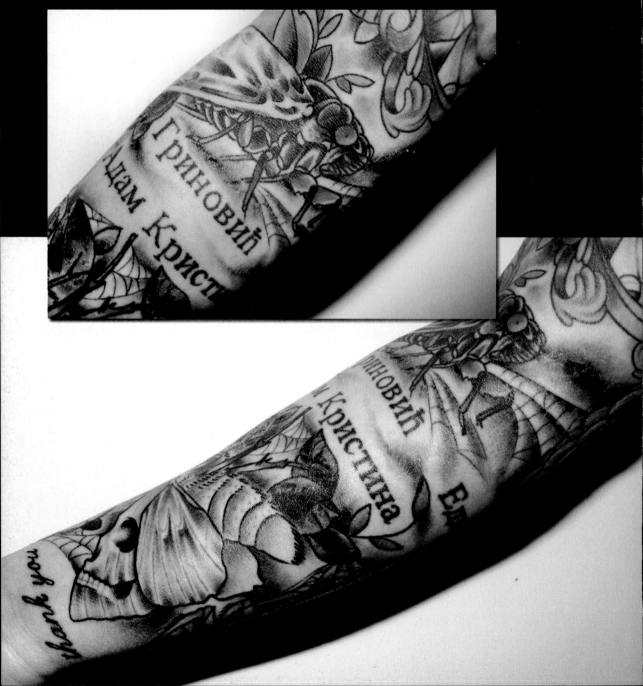

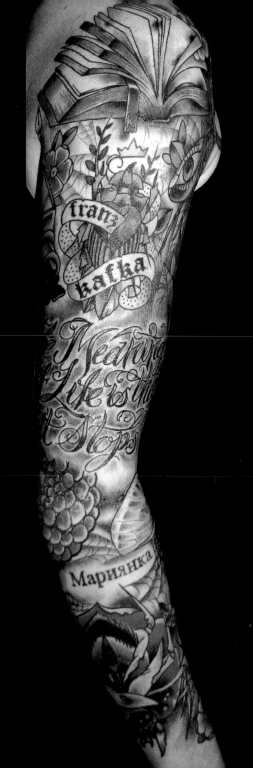

I decided to show my appreciation, gratitude, and respect for Kafka and how he has influenced my life and work by getting a Kafka-inspired sleeve. Along with a portrait on my inner bicep depicting the handsome writer, my right arm is entirely filled with metamorphosing beetles, bugs, flowers, an inkwell and pen, a book over my shoulder, and Kafka's quote "the meaning of life is that it stops," which reminds me every day that I am not immortal, and that I must leave my own mark while I can.

Lindsay F.
New York, New York

LINES FROM *A SEASON IN HELL* BY ARTHUR RIMBAUD

Translated, my tattoo means, "All that is over. Today I know how to greet beauty." One could also say that the speaker can "recognize" or "celebrate" beauty—translations differ. I am definitely partial to a literal translation of *saluer*, because the image of the speaker saying "hello" to beautiful things makes me happy. In Rimbaud's poem, this line comes after a long passage of dark and ugly delirium. While it may be read as ironic, I prefer to interpret it as a paradigm shift in the speaker's perspective, an honest choice to put away negative things in favor of positive ones.

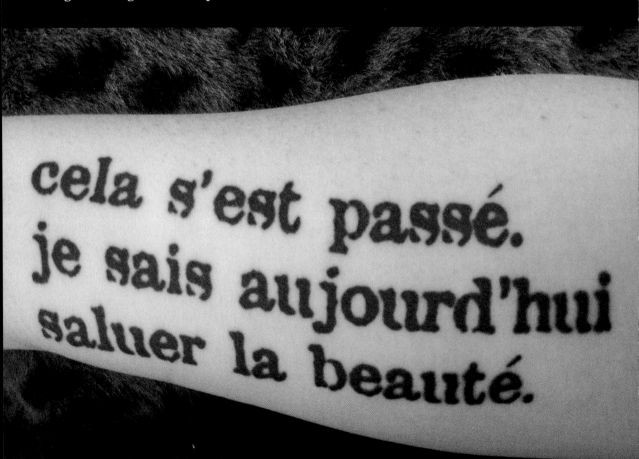

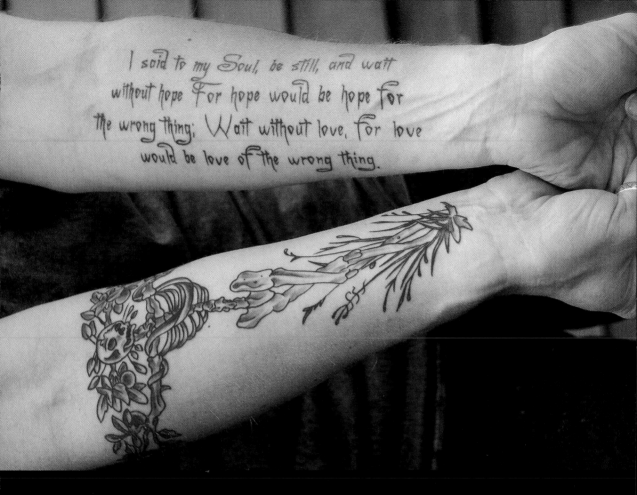

Elizabeth Vegvary
Cohasset, California

LINES FROM "EAST COKER" BY T. S. ELIOT

"East Coker" is the second of T. S. Eliot's *Four Quartets*. The words, the sentiment, the urging, have myriad meaning to me . . . and it's probably the next two lines, which weren't inked, that carry the most resonance. So, in a way, the tattoo is a bit like a koan or a meditation because when I read it, the uninked lines are finished inside my mind. On my right is the Tree of Knowledge from the Garden of Eden. He's pretty self-explanatory. A memento mori . . .

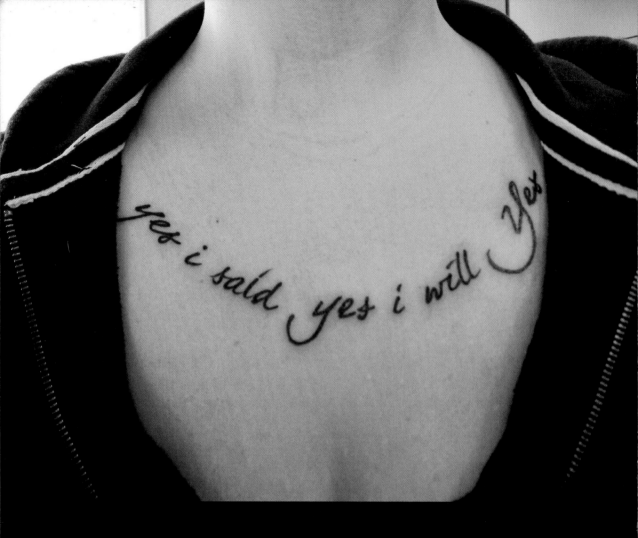

Jenni Ripley
Minneapolis, Minnesota

LAST LINE OF *ULYSSES* BY JAMES JOYCE

Jenni Ripley
Minneapolis, Minnesota

Jenni Ripley
Minneapolis, Minnesota

"SHANTIH"

This comes from the end of Eliot's "The Waste Land." He translated it as "the peace that passeth understanding." To me it conveys a sense of inner peace or serenity, a lack of conflict or turmoil with the outside world. The Upanishads traditionally end with *om shantih shantih shantih,* an invocation for peace and understanding. My favorite translation of that concept is "peace within, peace without, peace to the world."

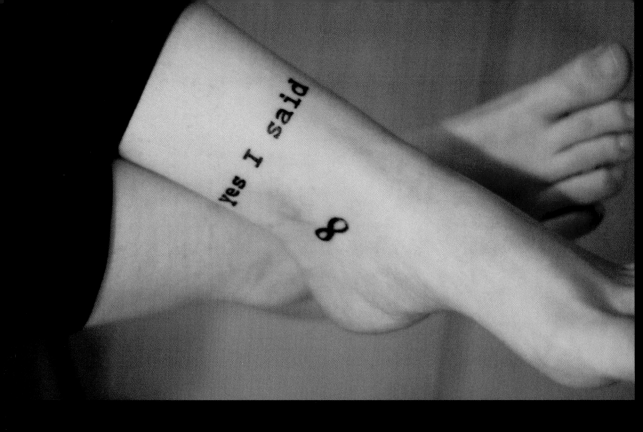

Natalie Lyalin and Lesley Yalen
Manayunk, Pennsylvania

"YES I SAID" / "YES I WILL YES"

We got these tattoos spontaneously after getting ever-so-slightly tipsy on cock-tails. The act was incredibly scary and fun. Linking ourselves with the ink felt right. I'm with you, you're with me—that sort of thing. The last chapter of *Ulysses*—Molly Bloom's soliloquy—is an enormous, twisting, complex movement, ending in Molly's re-membrance of Leopold's asking her to marry him and her unequivocal acceptance of love. Well, we are down with that. The tattoos seemed like a way to remind our-selves, 'cause we need reminding sometimes, of the great, active, restorative power of acceptance and the terrific leap of saying yes.

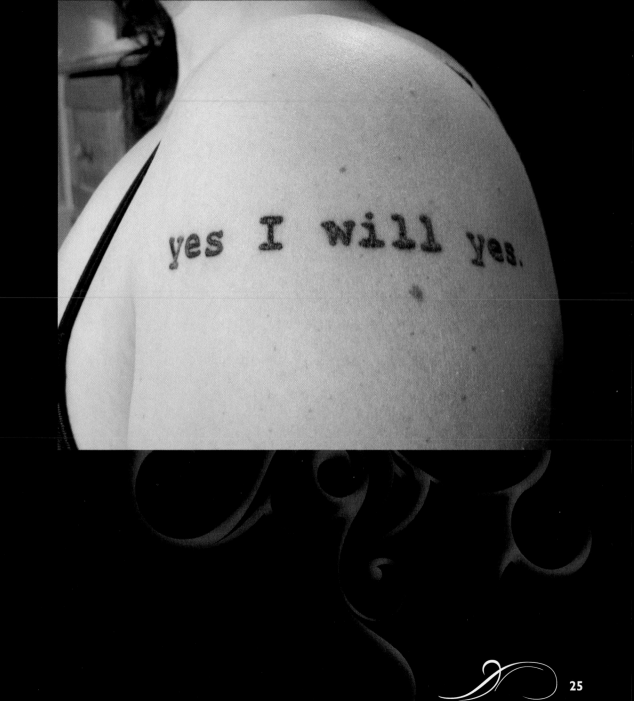

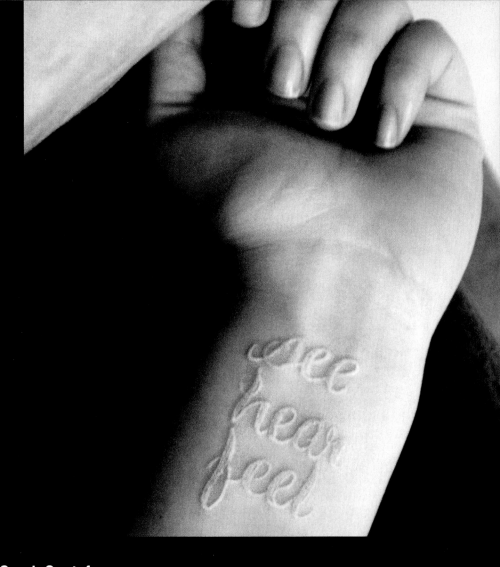

Sarah Spatafora
New York, New York, by way of the bayou

"SEE HEAR FEEL"

The tattoo comes from this line of the "Hades" episode in *Ulysses*, spoken by Leopold
Bloom: "Plenty to see and hear and feel yet."

James Claffey
Baton Rouge, Louisiana

LINES FROM "WORSTWARD HO!"
BY SAMUEL BECKETT

I got this tattoo after my first year of my second marriage and a particularly difficult Mardi Gras experience!

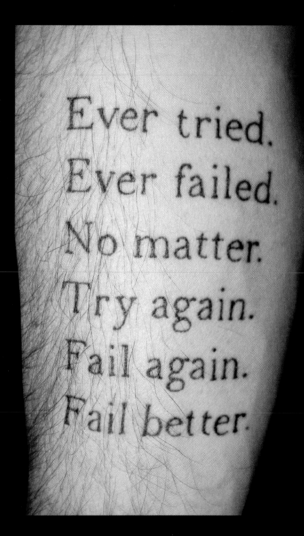

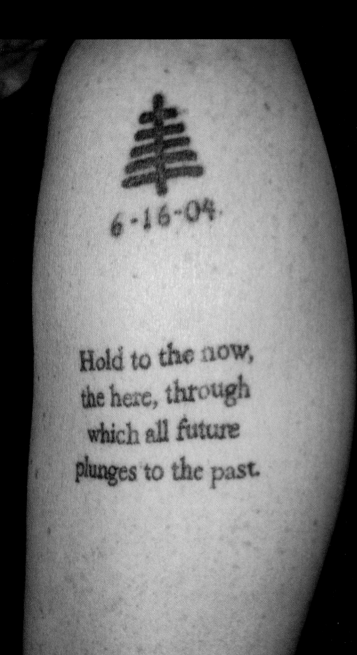

James Claffey
Baton Rouge, Louisiana

LINE FROM *ULYSSES*, WITH
COMMEMORATION OF BLOOMSDAY
AND HOMER'S GOLDEN LADDER

The golden ladder of Homer is
an early cross representing the
transmigration of the soul after
death (metempsychosis), which
Joyce writes of in *Ulysses*. The
date is Bloomsday, the day on
which *Ulysses* takes place.

Don Malkemes
New York, New York

LAST LINE OF *THE UNNAMABLE* BY SAMUEL BECKETT

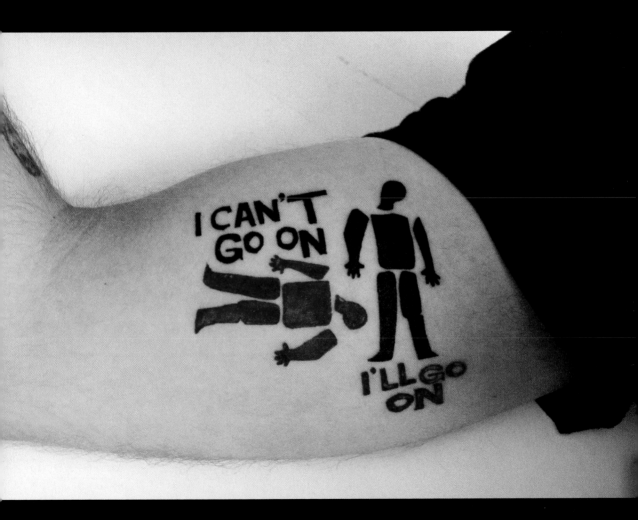

Katharine Barthelme

New York, New York

"The Baby" by Donald Barthelme

The first thing the baby did wrong was to tear pages out of her books. So we made a rule that each time she tore a page out of a book she had to stay alone in her room for four hours, behind the closed door. She was tearing out about a page a day, in the beginning, and the rule worked fairly well, although the crying and screaming from behind the closed door were unnerving. We reasoned that that was the price you had to pay, or part of the price you had to pay. But then as her grip improved she got to tearing out two pages at a time, which meant eight hours alone in her room, behind the closed door, which just doubled the annoyance for everybody. But she wouldn't quit doing it. And then as time went on we began getting days when she tore out three or four pages, which put her alone in her room for as much as sixteen hours at a stretch, interfering with normal feeding and worrying my wife. But I felt that if you made a rule you had to stick to it, had to be consistent, otherwise they get the wrong idea. She was about fourteen months old or fifteen months old at that point. Often, of course, she'd go to sleep, after an hour or so of yelling, that was a mercy. Her room was very nice, with a nice wooden rocking horse and practically a hundred dolls and stuffed animals. Lots of things to do in that room if you used your time wisely, puzzles and things. Unfortunately sometimes when we opened the door we'd find that she'd torn more pages out of more books while she was inside, and these pages had to be added to the total, in fairness.

The baby's name was Born Dancin'. We gave the baby some of our wine, red, whites and blue, and spoke seriously to her. But it didn't do any good.

I must say she got real clever. You'd come up to her where she was playing on the floor, in those rare times when she was out of her room, and there'd be a book there, open beside her, and you'd inspect it and it would look perfectly all right. And then you'd look closely and you'd find a page that had one little corner torn, could easily pass for ordinary wear-

and-tear, but I knew what she'd done, she'd torn off this little corner and swallowed it. So that had to count and it did. They will go to any lengths to thwart you. My wife said that maybe we were being too rigid and that the baby was losing weight. But I pointed out to her that the baby had a long life to live and had to live in a world with others, had to live in a world where there were many, many rules, and if you couldn't learn to play by the rules you were going to be left out in the cold with no character, shunned and ostracized by everyone. The longest we ever kept her in her room consecutive was eighty-eight hours, and that ended when my wife took the door off its hinges with a crowbar even though the baby still owed us twelve hours because she was working off twenty-five pages. I put the door back on its hinges and added a big lock, one that opened only if you put a magnetic card in a slot, and I kept the card.

But things didn't improve. The baby would come out of her room like a bat out of hell and rush to the nearest book, *Goodnight Moon* or whatever, and begin tearing pages out of it hand over fist. I mean there'd be thirty-four pages of *Goodnight Moon* on the floor in ten seconds. Plus the covers. I began to get a little worried. When I added up her indebtedness, in terms of hours, I could see that she wasn't going to get out of her room until 1992, if then. Also, she was looking pretty wan. She hadn't been to the park in weeks. We had more or less of an ethical crisis on our hands.

I solved it by declaring that it was *all right* to tear pages out of books, and moreover, that it was all right to *have torn* pages out of books in the past. That is one of the satisfying things about being a parent—you've got a lot of moves, each one good as gold. The baby and I sit happily on the floor, side by side, tearing pages out of books, and sometimes, just for fun, we go out on the street and smash a windshield together.

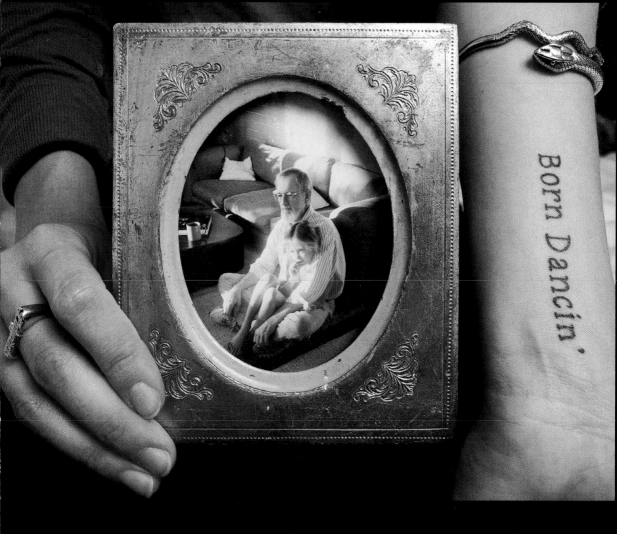

BORN DANCIN'

KATHARINE BARTHELME, HOLDING A PHOTOGRAPH OF HERSELF WITH HER FATHER

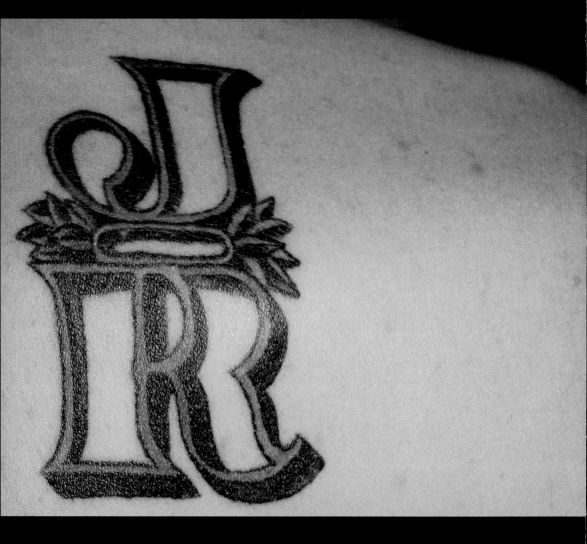

Mark Iosifescu
New York, New York

TITLE OF *J R* BY WILLIAM GADDIS, IN THE STYLE OF THE ORIGINAL COVER

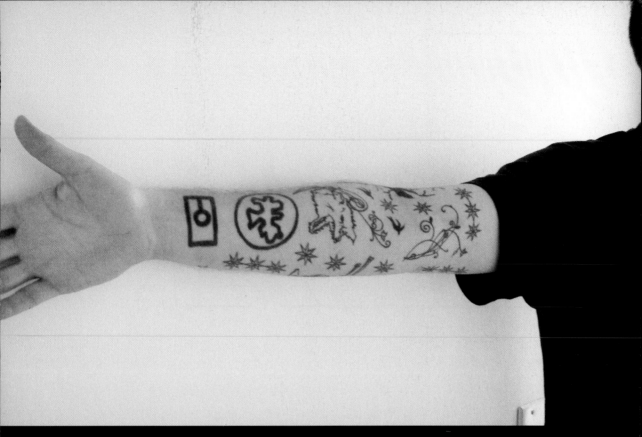

Brandon Stosuy
New York, New York

MAP FROM *THE TUNNEL* BY WILLIAM H. GASS, AND ALCHEMY SYMBOL IN HOMAGE TO YEATS

I got all of my literary tattoos when I was young. I went for *The Tunnel* in 1995, shortly after finishing the book, and a year or so after William H. Gass lectured in a class of mine and blew my mind. I don't think of *The Tunnel* as a great novel—I always preferred his essays—but I'd e-mailed Gass as a teenager and he gave me a reading list that included Thomas Bernhard, Cortázar, Hermann Broch, Colette, Ford Madox Ford, Stein, etc. So the tattoo's a homage to getting started. The tattoo beneath the Gass is an alchemy symbol referencing all the Yeats I was reading at some point. Very romantic of me.

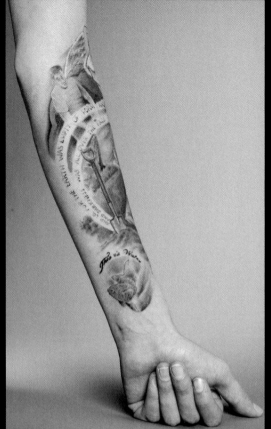
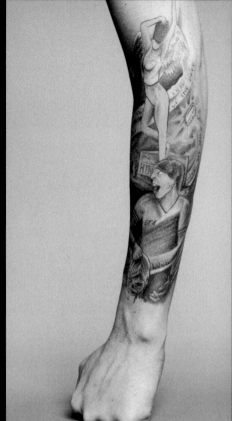

David Wegehaupt
Tempe, Arizona

SLEEVE DEPICTING SCENES FROM *INFINITE JEST*
BY DAVID FOSTER WALLACE

The image is conjured from two brief mentions of an encounter that happens during a yearlong gap in time within the book, when the two main characters, Hal Incandenza and Don Gately, meet in order to dig up the grave of Hal's father, the filmmaker of *Infinite Jest*.

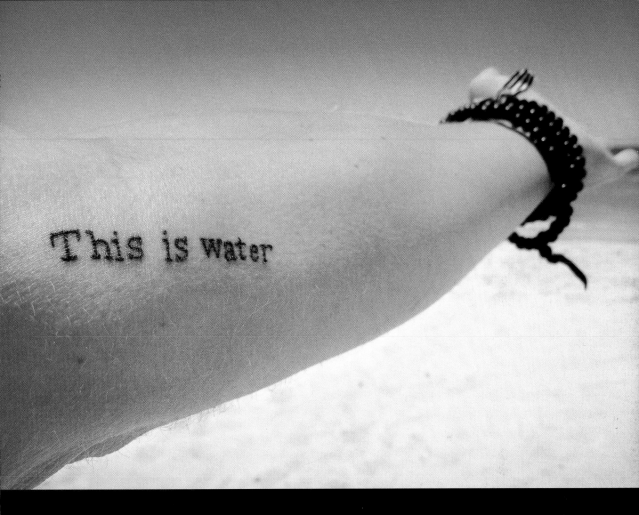

Sam de Brito
Manly, New South Wales, Australia

"THIS IS WATER" TITLE OF A COMMENCEMENT SPEECH GIVEN BY DAVID FOSTER WALLACE
AT KENYON COLLEGE, TO THE GRADUATING CLASS OF 2005

My girlfriend and I got this on our arms while traveling in New Zealand at
Christmas in 2007. It was done by a Maori police officer who did tattooing as
a hobby but wanted to start his own shop called the Thin Blue Line.

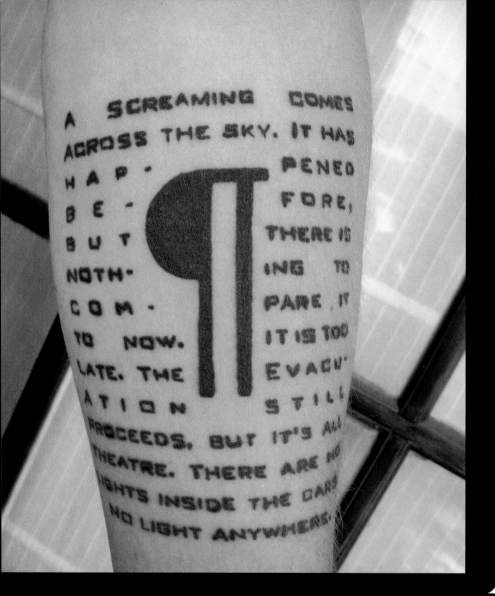

John Singleton
Los Angeles, California

OPENING LINES OF *GRAVITY'S RAINBOW* AND PILCROW (TYPOGRAPHER'S
SYMBOL FOR A PARAGRAPH)

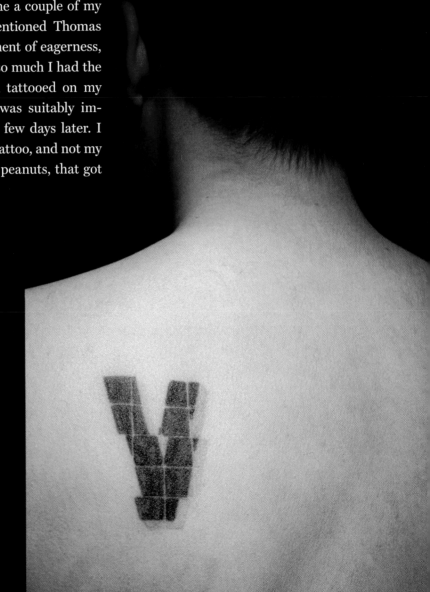

Ryan Chapman
New York, New York

TITLE OF *V* BY THOMAS PYNCHON

During my first job interview in publishing, I was asked to name a couple of my favorite novelists. I mentioned Thomas Pynchon and, in a moment of eagerness, added that I liked him so much I had the name of his first novel tattooed on my back. The interviewer was suitably impressed; he hired me a few days later. I like to think it was the tattoo, and not my willingness to work for peanuts, that got me the job.

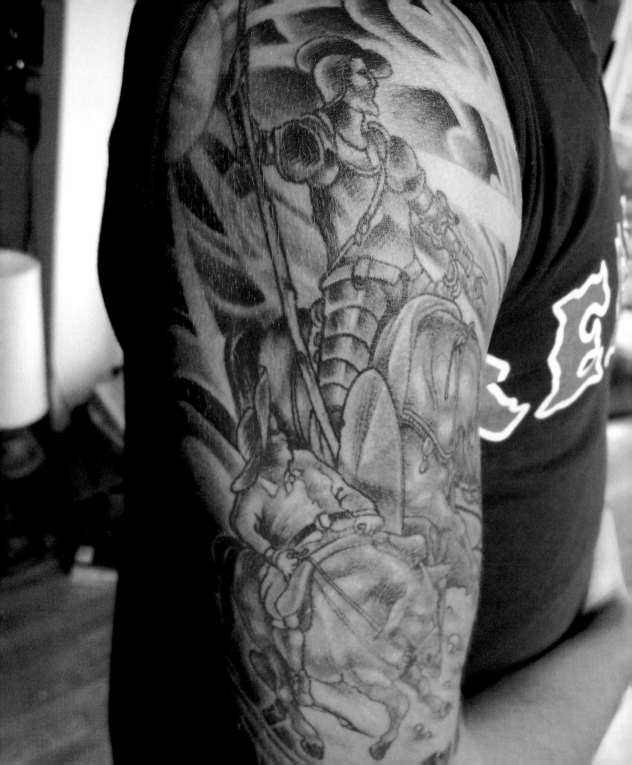

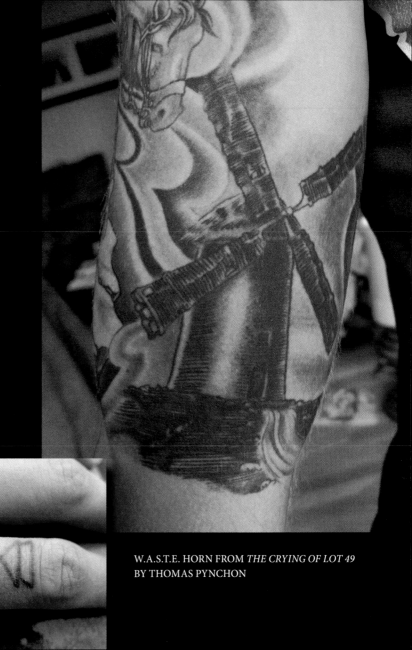

Ryan
Seattle, Washington

SCENES FROM DON QUIXOTE BY
MIGUEL DE CERVANTES

W.A.S.T.E. HORN FROM *THE CRYING OF LOT 49*
BY THOMAS PYNCHON

Erin M.
Pasadena, California

"Nostos Algos," from *Ignorance* by Milan Kundera. Here is the passage this is taken from:

> *The Greek word for "return" is* nostos. Algos *means "suffering." So nostalgia is the suffering caused by an unappeased yearning to return . . . In that etymological light nostalgia seems something like the pain of ignorance, of not knowing. "You are far away, and I don't know what has become of you."*

Kundera's novels hold a special place in my heart as I was first introduced to him by one of my favorite teachers in college, Bill Yarrow (of Joliet Junior College, Joliet, Illinois). In February of 2006, I picked up *Ignorance* on a whim one day and finished the book in a few hours—I couldn't put it down. I've always been fascinated by human memory: how terrible it is, how extraordinary. How—as a person—life is full of comings and goings, and unfortunately memory is only able to hold on to a small fraction of "these meetings, these partings" (Woolf, *The Waves*). After I finished *Ignorance*, I was so moved that I called a tattoo parlor near my house and got this tattoo a few hours later. It's my first and only one.

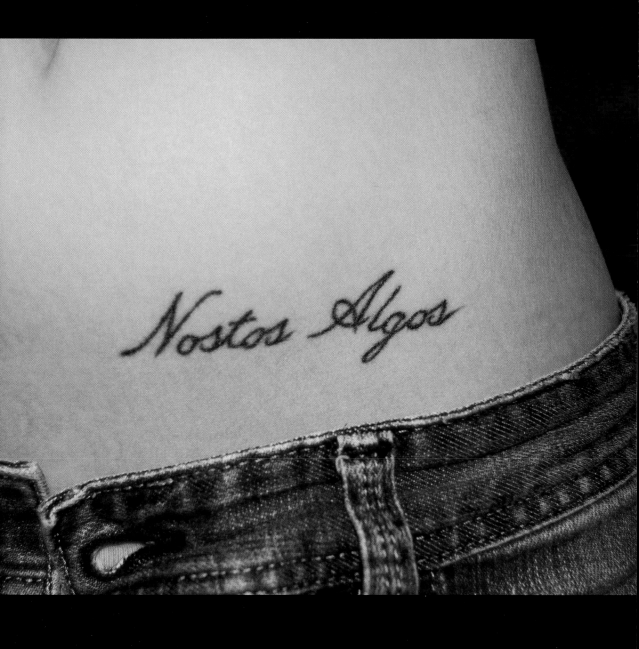

Shelley Jackson

New York, New York

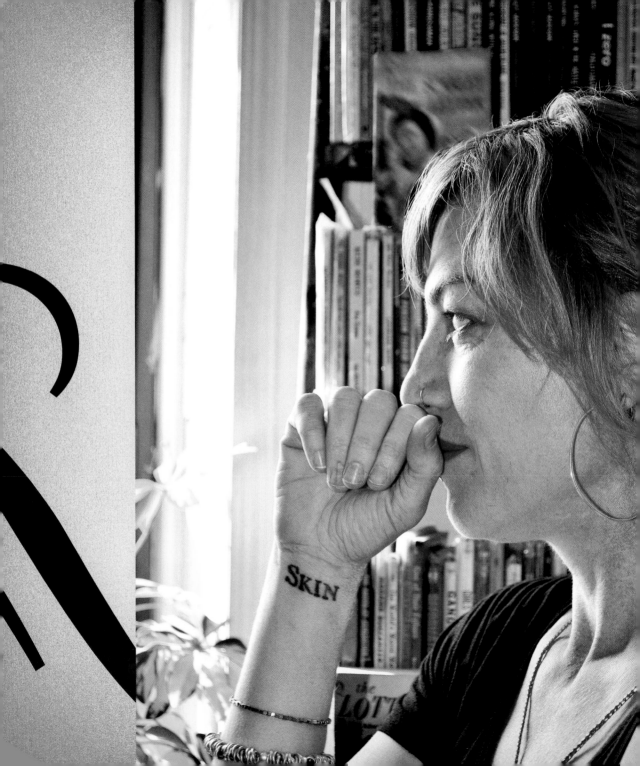

Original Press Release for "SKIN"
For Immediate Release
Saturday, July 26, 2003
Author Announces Mortal Work of Art

Writer Shelley Jackson invites volunteers for a new work entitled "Skin." Each participant agrees to have one word of a story tattooed upon his or her body. The text will be published nowhere else, and the author will not permit it to be summarized, quoted, described, set to music, or adapted for film, theater, television, or any other medium. The full text will be known only to participants, who may, but need not choose to establish communication with one another. If insufficient participants come forward to complete the first and only edition of the story, the incomplete version will be considered definitive. If no participants come forward, this call itself is the work.

Prospective participants should contact the author and explain their interest in the work. If accepted, they must sign a waiver releasing the author from any responsibility for health problems, body-image disorders, job losses, or relationship difficulties that may result. The author will reply with a letter specifying the word (or word plus punctuation mark) assigned to the participant. Participants must accept the word they are given, but they may choose the site of their tattoo, with the exception of words naming specific body parts, which (with the exception of the word "skin") may be anywhere but on the body part named. Tattoos must be in black ink and a classic book font. Words in fanciful fonts will be expunged from the work.

When the work has been completed, participants must send the author a signed and dated close-up of the tattoo and a portrait in which the tattoo is not visible. Participants will receive in return a

certificate confirming their participation in the work and verifying the authenticity of their word. Author retains copyright, though she contracts not to devalue the original work with subsequent editions, transcripts, or synopses. However, correspondence and other documentation pertaining to the work will be considered for publication.

From this time on, participants will be known as "words." They are not understood as carriers or agents of the texts they bear, but as their embodiments. As a result, injuries to the tattooed text, such as dermabrasion, laser surgery, cover work, or the loss of body parts, will not be considered to alter the work. Only the death of words effaces them from the text. As words die the story will change; when the last word dies the story will also have died. The author will make every effort to attend the funerals of her words.

Five Words from the "SKIN" Project

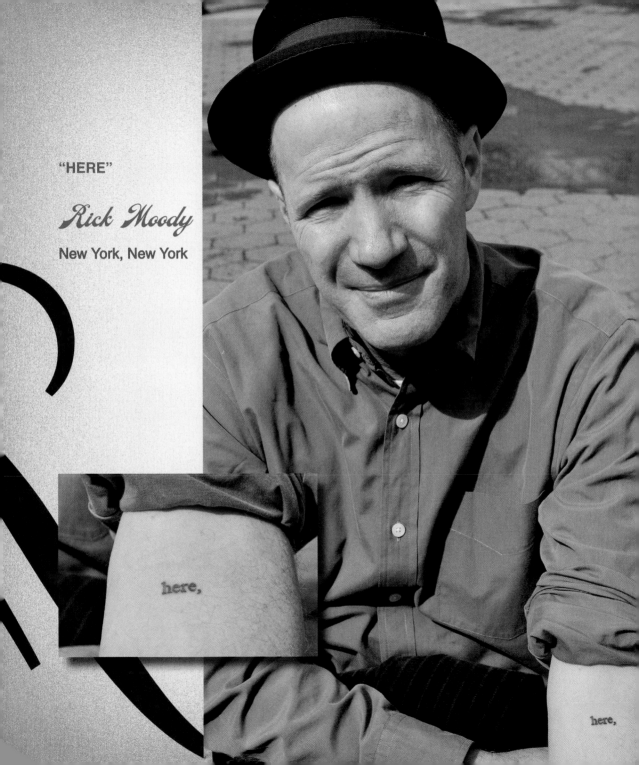

"HERE"

Rick Moody

New York, New York

Alexis Turner

Chicago, Illinois

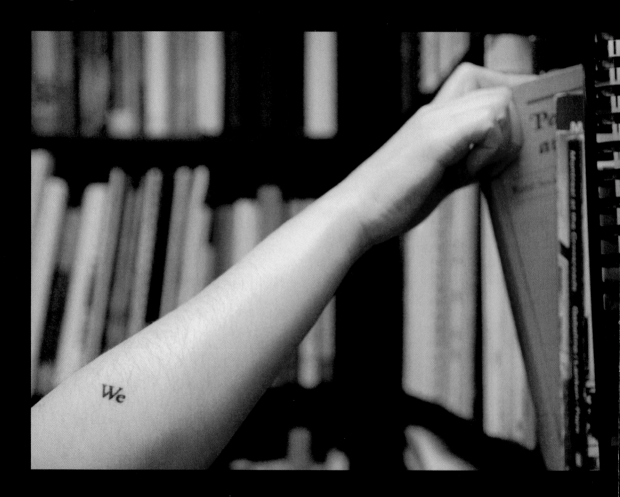

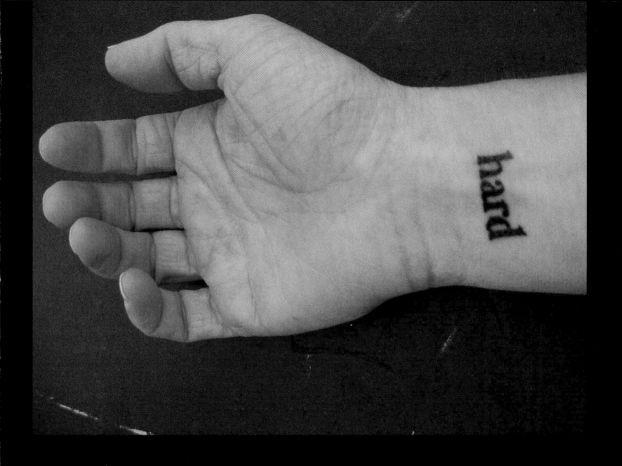

"HARD"

Liz Coffey

Roxbury, Massachusetts

Emily Hall and Phil Campbell

Brooklyn, New York

My wife Emily Hall and I have tattoos from Shelley Jackson's "SKIN," a 2,095-word short story published not on paper but as individual words on people's bodies. "Skin" doesn't exist anywhere but as tattoos on people who are scattered all around the world. Skin participants are members of a living, breathing work of literature.

We are words.

My wife is "of"; I am "law," comma included. We exist together as a prepositional phrase somewhere near the middle of Jackson's story.

The "SKIN" tattoo symbolizes the significant insignificance that is contemporary life. From online social networks to our neighborhoods to our places of work, we belong to dozens of different kinds of communities at any single moment. Belonging to "SKIN" is a metaphorical kind of belonging. I've met a handful of the other words, but that's only because I live in New York. A word who lives in rural Idaho may never meet another word, much less Jackson herself, whose tattoo "SKIN" serves as the title of the story. The relationship is beautifully abstract.

Jackson once told me that she may put a book together that compiles photos of all the words of "SKIN." It would be a collection of Polaroids of the arms, legs, toes, thighs, and other anatomical places where her words exist. But Jackson would not organize the book in the order in which the short story is told—the words would be all scrambled up. I hope she does this; I would like to assemble all these words and try to discover the short story myself. The litera-

ture of "SKIN" then becomes a jigsaw puzzle, with capitalized words serving as potential "edge" pieces, and with words that include punctuation marks like periods and colons hinting at their own places in the order of Jackson's story.

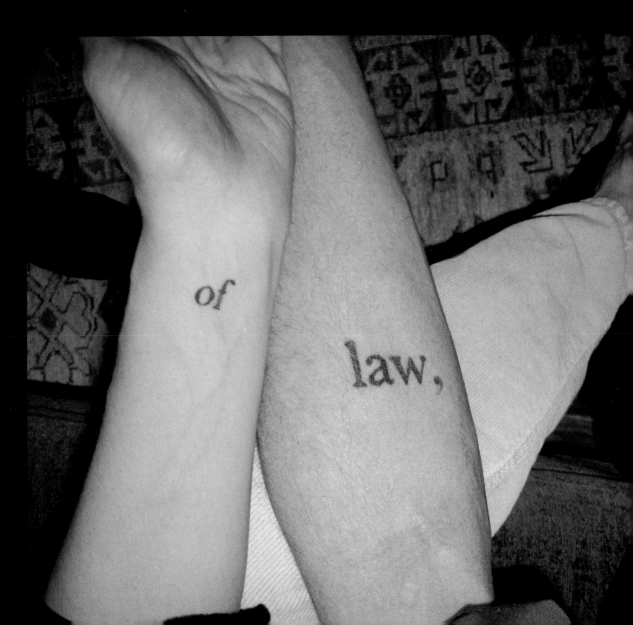

"SKIN" by the Numbers

Project launched: August 2003

Title and first word inked: Monday, September 8, Bowery Tattoo, New York

Current status: in process, with a focus on mailing stories to participants who have sent in documentation of their completed tattoos.

Number of volunteers provisionally accepted to date: approximately 1,875 of 2,095

Number of releases actually received: 1,449

Words mailed out: 1,445

Words assigned but not yet mailed: 4

Words inked: approximately 553

Stories sent: 372

Openings for new participants: 646 or more (depending on dropouts)

Number of volunteers: more than 10,000

Total number of e-mails received related to this project: 21,894

Oldest participant: 71

Youngest participant: 22

Average age: about 32

Gender: about 56 percent female, 44 percent male

GEOGRAPHICAL DISTRIBUTION

36 Australia	3 Japan
15 Argentina	1 Jordan
1 Austria	17 Netherlands
10 Belgium	3 New Zealand
1 Bermuda	5 Norway
3 Brazil	1 Poland
121 Canada	4 Scotland
1 Colombia	2 South Africa
1 Denmark	4 Sweden
6 Finland	1 Thailand
7 France	1 Turkey
5 Germany	82 United Kingdom
1 Iceland	1,103 United States
3 Ireland	

et in Arcadia ego

Kathryn Greenbaum
New York, New York

LINE FROM *BRIDESHEAD REVISITED* BY EVELYN WAUGH

The phrase is Latin, and is the title of two seminal Nicolas Poussin paintings from the 1600s. There are multiple translations of the phrase, which is meant as a memento mori and is spoken by a personified Death. The most used translation is "Even in Arcadia I exist;" another translation is "I too was once an Arcadian." In *Brideshead Revisited*, the novel's narrator has a decorative human skull with the phrase etched into its forehead. I got the tattoo both for its literary significance, as well as for the translation, which is a reminder that death is always present, even when things may seem to be perfect.

Cordelia Brodsky
Valencia, Spain

ILLUSTRATIONS FROM THE FIRST EDITION OF *SALOME* BY OSCAR WILDE

The original Aubrey Beardsley illustrations for *Salomé* were in black-and-white; however, all my other work is in color, and I felt like the design would flow better with me in color; I also wanted to make the design ever-so-slightly less morbid than the original. As it is, people often say, "oh what a pretty tattoo," upon seeing the cheerful colors and flowers, and I say of course thanks, and get a special glee out of pointing out that it depicts one of the great historical antiheroines kissing the decapitated head of John the Baptist. I first read Oscar Wilde in college and he's one of the literary figures who has stuck with me over the years as a point of reference, both as a cultural figure and a progenitor of queer culture, and as an author of unparalleled wit and acuity. Aubrey Beardsley's work never ceases to amaze me, and the story of Salomé fits with certain personal narratives of mine. At the time we did the tattoo, I was dating an abusive bastard who shared a certain prophet's willingness to condemn. He was not amused by the tattoo. We broke up shortly thereafter.

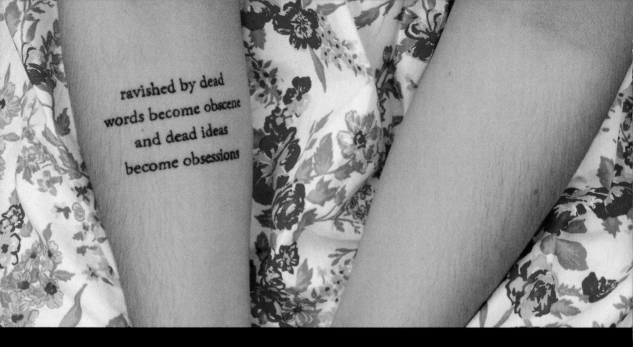

ravished by dead
words become obscene
and dead ideas
become obsessions

Selena Salihovic
Seattle, Washington

SENTENCE FROM *LADY CHATTERLEY'S LOVER* BY D. H. LAWRENCE

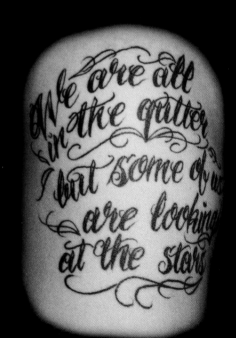

Ari Oh
Los Angeles, California

LINE FROM *LADY WINDERMERE'S FAN* BY OSCAR WILDE

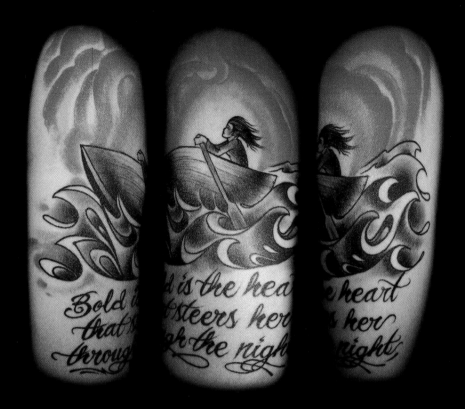

Ari Oh
Los Angeles, California

ILLUSTRATION OF A SCENE IN *A HERO OF OUR TIME* BY MIKHAIL LERMONTOV

A young girl standing on the roof of a hut sings a song about a girl at sea on the ocean among giant ships. While they have giant sails and can last through the storms, her small boat has only two oars. She asks the ocean to have pity on her boat, because "precious are the goods that my boat carries; bold is the heart that steers her through the night."

Richard Sullivan
Dallas, Texas

OPENING LINE OF *NOTES FROM UNDERGROUND* WITH A PORTRAIT OF DMITRY KARAMAZOV FROM *THE BROTHERS KARAMAZOV*, BOTH BOOKS BY FYODOR DOSTOYEVSKY

I bonded with Dostoyevsky over our mutual understanding of the human condition, its depravity. The text is a confession, a repentance. The rag full of money, which terrorized Dmitry, is his human frailty and failing. You could say the combination of the text, inasmuch as it is penitent, and the position of Dmitry's arm and hand on the rag, depict the beginning of his ascension through the torments represented by the criminal interrogation he undergoes. It is Dmitry in the middle of the Gospel, forgiveness in transit. Suffice to say, I can relate.

Jamie "Scapegoat" Garvey
Gainesville, Florida

COVER OF *DEAD SOULS* BY NIKOLAI GOGOL

I read *Dead Souls* when I worked at a sex shop here in Gainesville, Florida. I had just come out of a two-year relationship with an English major and basically felt illiterate, so I started reading everything that I could get my hands on that I might have read had I been diligent enough to actually attend college.

I made a xerox of the cover on the copy machine we had and kept it in my drawer as a tattoo idea. I waited over three years to actually get it, but I am glad that I did.

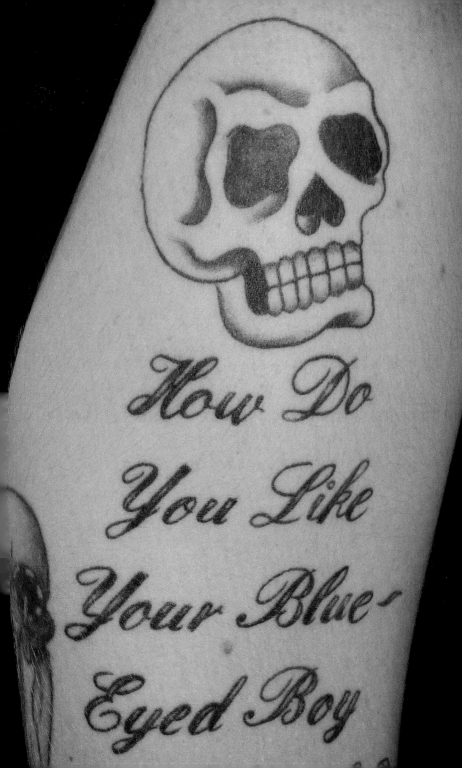

Jamie "Scapegoat" Garvey
Gainesville, Florida

THE SAME E. E. CUMMINGS TATTOO THAT HARRY CREWS HAS

I first found out about Harry Crews from my friend Billie Joe from the band Future Virgins. We were at my house tripping on mushrooms and Billie said, "I have the phone number for my favorite author. He lives here in town." He then called Harry Crews up and had a conversation with him. He tried several times to meet Crews, but Crews kept ducking him. One day I found a copy of A *Feast of Snakes* at a furniture store where I was working at the time. I read it and it blew my mind. I decided I was going to call Crews and see if I could get the book signed for Billie. I somehow convinced him to let me come over, and I ended up helping him out with some household chores. When Billie's band came through on tour, I took him over to Crews' house to finally meet him.

After that I started going over to his house regularly to help out with basic stuff and to shoot the shit. When I showed him the tattoo, I thought he was going to whip my ass, but instead he was like, "I don't have a trademark on that. That is some beautiful work." Since then Crews has become one of my favorite friends, and the sessions at his house, shooting the shit over coffee and cigarettes, are some of the most valuable experiences I have ever had.

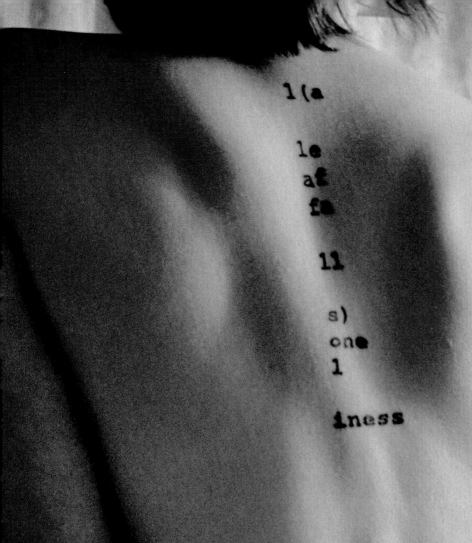

l(a

le
af
fa

ll

s)
one
l

iness

Hannah Kucharzak
Chicago, Illinois

"1(A . . . (A LEAF FALLS ON LONELINESS)"; COMPLETE POEM
BY E. E. CUMMINGS

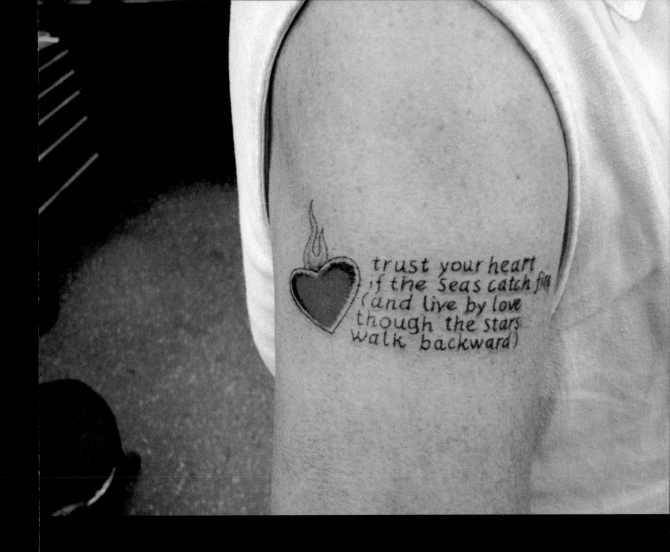

Alex Fletcher
Los Alamitos, California

LINES FROM "DIVE FOR DREAMS" BY E. E. CUMMINGS

From an e. e. cummings poem that I memorized when I was twenty-one years old . . . I'm fifty-two now, and the poem still speaks to me.

67

be of love(a little)
More careful
Than of everything

Nicole Karas
Albany, New York

OPENING OF "BE OF LOVE" BY E. E. CUMMINGS

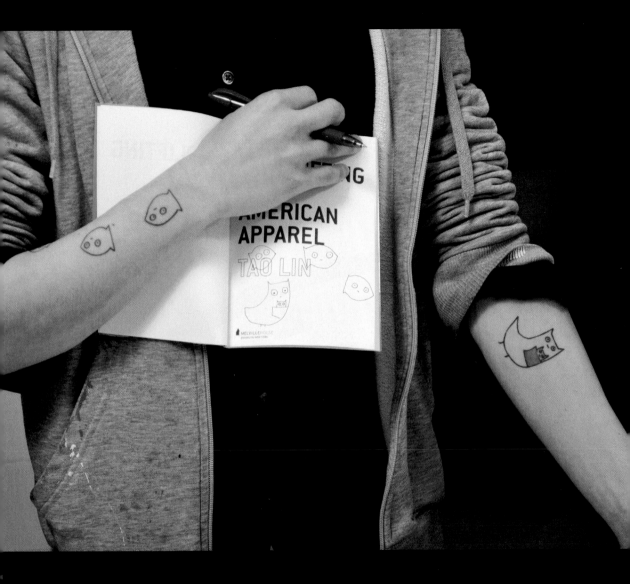

Tao Lin
Brooklyn, New York

TAO LIN, WITH THE LITTLE CREATURES HE SIGNS HIS BOOKS WITH

Robert Lee Emigh III

Boulder, Colorado

Lines from Brian Evenson's *Dark Property* and Brian Evenson's Response

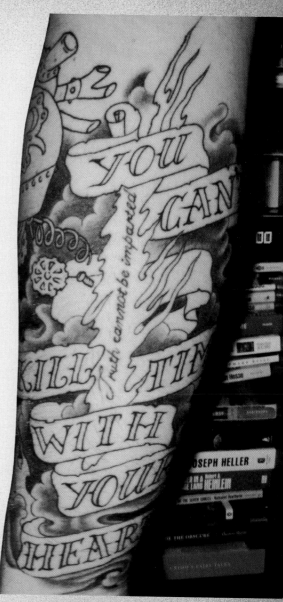

The text reads "Truth cannot be imparted" on the right inner forearm and "Truth must be inflicted" on the left. When I read these lines, it was like being kicked in the face—which isn't to say that the entire novel isn't like being kicked in the face, but reading this passage was one of those wonderful and rare moments when an author stated something that I had long believed, but hadn't yet found the words to express. It's an acknowledgment that understanding is no substitute for experience. Which I suppose applies to all the text tattooed on me (it's imparting something after all, yes?), but I think of it more as an expression of the "truth" that's been inflicted on me than as a message to the world.

Around the Evenson text on the right arm, there's a banner that says, "You can't kill time with your heart" (from David Foster Wallace's short story, "Forever Overhead"). Going around, there's a mechanical/clockwork heart that's spilling a few of its parts, and around further, there's "Empty space and points of light," from Jeanette Winterson's novel *Sexing the Cherry*.

See Brian Evenson's response on the next page!

I first met Robert Emigh at an Associated Writing Program conference in Chicago when he came up to me and said, "Are you Brian Evenson?" When I said yes, he dropped what he was carrying and rolled up his sleeves to show me his forearms, where he'd tattoed words from my novella Dark Property. "Truth cannot be imparted," read one arm. "Truth must be inflicted," read the other. It was at once a flattering experience and a somewhat unsettling one: I'd thought in the abstract about the way in which books and the world interact, about the way they code and recode one another in a nonaparallel fashion. But despite that it was a very odd thing to see words that one recognizes as one's own go from being inscribed on paper to being inscribed on someone else's flesh.

So on the one hand (or perhaps I should say on the one forearm) I was thinking, "What better indication that you've reached something, arrived somewhere than to see your words migrating from paper to flesh?" On the other hand, I was thinking, "This is a little bit frightening. Robert, are you sure you really want to live with these words for so long?" I think my response was complicated by what the words themselves were, the notion that the tattoo was a kind of infliction, and as such a kind of interpretation/complication/ translation of my phrase—I've come to think that it's a very smart and complicated response and that Robert was taking it a step further than I had, was pursuing a path along a line that I'd begun but hadn't completed.

Since that initial encounter I've gotten to know Robert a little more, have clearly confirmed the fact that he's a nice

guy and a good writer rather than a stalker, and have come to feel he has a right to my words if he feels strongly enough about them to tattoo them on his body—and maybe even has more of a right to them than me. It's become less and less frightening and more and more flattering.

—FROM BRIAN EVENSON

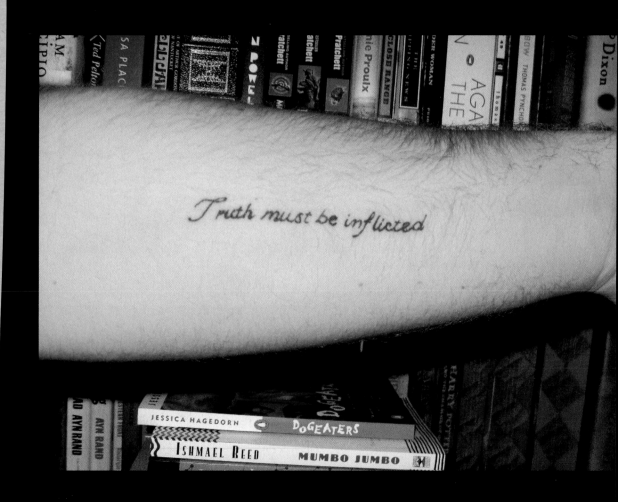

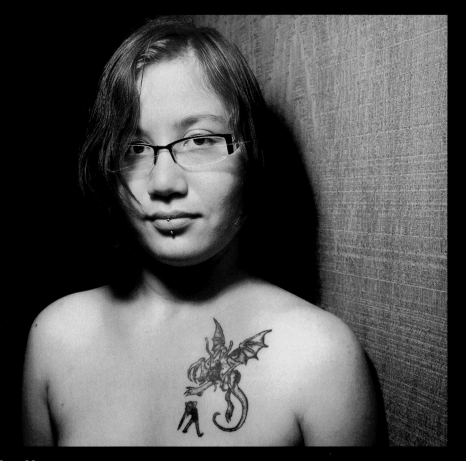

Loraine Ho
Honolulu, Hawaii

"JABBERWOCKY" ILLUSTRATION FROM *THROUGH THE LOOKING-GLASS AND WHAT ALICE FOUND THERE* BY LEWIS CARROLL

Carroll's "Jabberwocky" was the first poem I ever memorized, and I love how he plays with nonsense words to set up an epic battle. Many of those gibberish words have slipped into the English vocabulary and can now be found in the dictionary. I feel like this is representative of how our language is ever-growing, changing, and alive. The illustration, created by Sir John Tenniel for the book, depicts Carroll's mythical Jabberwock and the prince who slays it.

Laura Hartrich
Central Illinois

SCENE FROM *THE RUNAWAY BUNNY* BY MARGARET WISE BROWN, WITH ILLUSTRATIONS BY CLEMENT HURD

I asked the artist to replicate the image from the book as closely as possible, with the exception of adding another flying bunny. I needed two to represent my two sons. For me, this tattoo is a promise to my boys. They will fly away from me, as children inevitably do. My aim is to encourage them as they make their own way in the world, and also to be a safe place to land whenever they need to come back home.

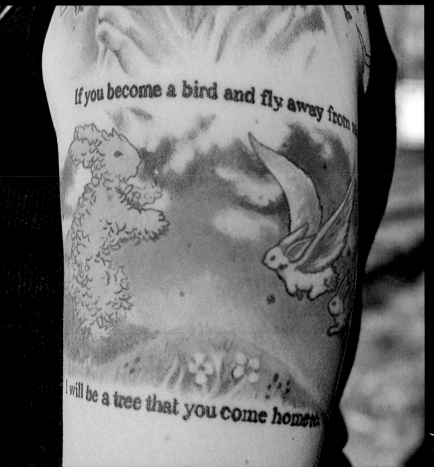

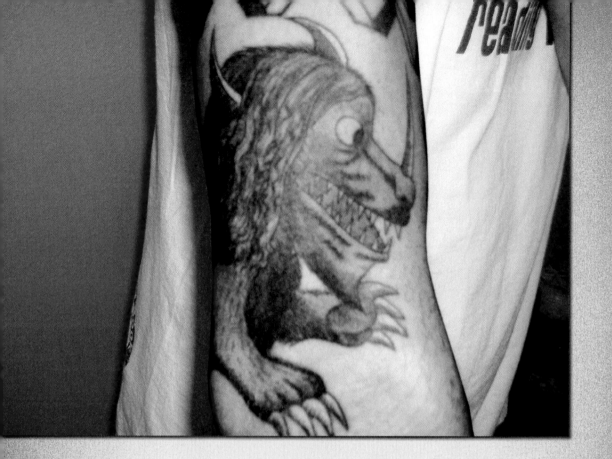

Kyle Larson
Fort Collins, Colorado

ILLUSTRATIONS FROM *WHERE THE WILD THINGS ARE* BY MAURICE SENDAK

I am the father of three beautiful girls. My oldest was born when I was nineteen, just around the time I started getting tattoos, and had an impact on the types of things I put on my body. I wanted tattoos that my children would love, but that also spoke to my personality.

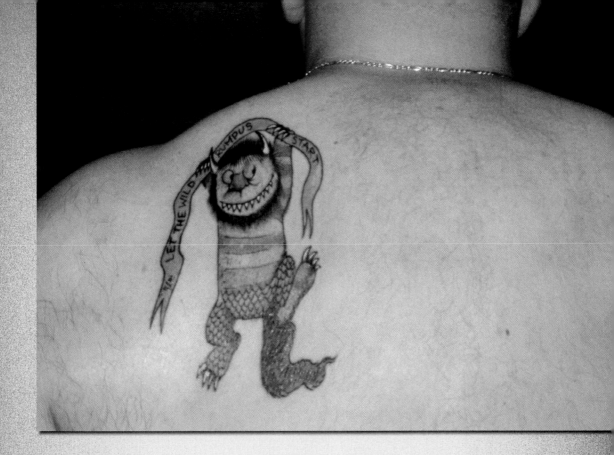

Joe Corridori
Jamesville, New York

"LET THE WILD RUMPUS START," WITH ILLUSTRATION, FROM *WHERE THE WILD THINGS ARE* BY
MAURICE SENDAK

As an English teacher, I knew I wanted my first (and so far, only) tattoo to have some
sort of literary element in addition to its symbolic significance. I got this the day school
let out in June of '09, roughly a month after my divorce was finalized, and just three
days before I was setting out on a cross-country drive to see the country and plenty of
friends along the way. I know this is going to sound corny as hell, but although it's on
my back shoulder, I really felt its presence as I drove away from all the stress associ-
ated with the divorce and toward an adventure that was entirely mine to seek.

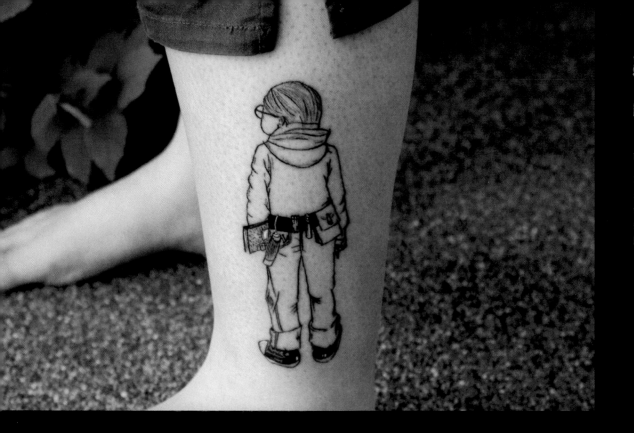

Jennifer C. Calgary
Alberta, Canada

ILLUSTRATION FROM *HARRIET THE SPY* BY LOUISE FITZHUGH

This book has a magical quality for me. My copy is tattered and also crinkled from dropping it in the bathtub numerous times. But I just can't replace it. It's been with me forever like an old friend. Louise Fitzhugh illustrated the book herself, and I always loved the image of Harriet in her hooded sweatshirt and her spy tool belt. It was the perfect piece of art for my first tattoo.

Victor Shey
Brooklyn, New York

ILLUSTRATION FROM *HECTOR THE COLLECTOR*
BY SHEL SILVERSTEIN

Betty Williams
Cape Girardeau, Missouri

ILLUSTRATION FROM *WHERE THE SIDE-WALK ENDS* BY SHEL SILVERSTEIN

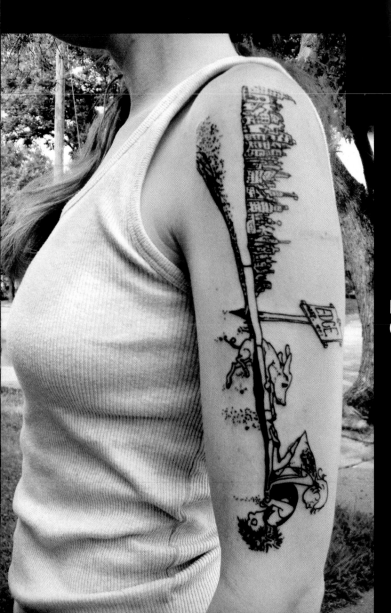

79

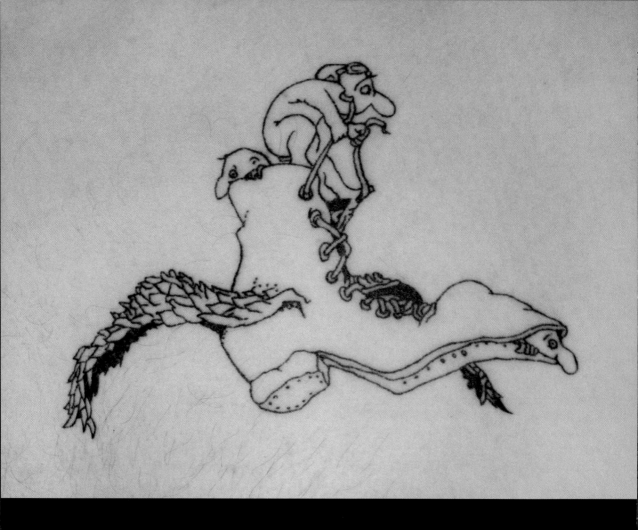

Grant Guilliams
Brooklyn, New York

ILLUSTRATION FROM *ICKLE ME, TICKLE ME, PICKLE ME TOO* BY SHEL SILVERSTEIN

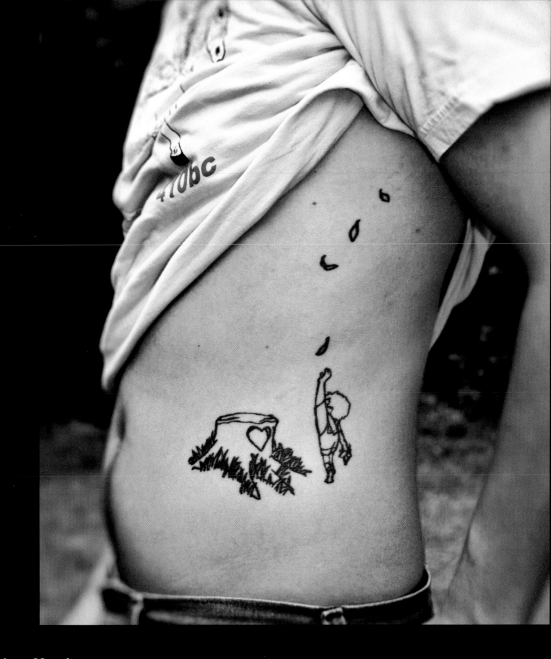

Nathan Morris
Montgomery, Alabama

ILLUSTRATION FROM *THE GIVING TREE* BY SHEL SILVERSTEIN

Becky Quiroga
Coral Gables, Florida

ORIGINAL DRAWING BY ERIC CARLE OF HIS VERY HUNGRY CATERPILLAR

Working for Books & Books in Coral Gables, Florida, where we average sixty author events a month, I am constantly presented with opportunities to meet well-known authors and illustrators. But when Eric Carle dropped by for lunch and a little stock signing, I was presented with my only tattoo opportunity. The instant I heard of his visit, I declared that I'd have him draw *The Very Hungry Caterpillar* on my arm and then have it made permanent. Still, I was a bit hesitant when I approached him bearing a Sharpie. No need for nervousness. He joyfully agreed, sketching the caterpillar on my arm and signing his name underneath. He got really into it, telling me to make sure the tattoo artist could differentiate between the dot of his signature's '*i*' and the caterpillar's legs.

Glowing, I left work early and raced to Tattoos by Lou in North Miami with a copy of the book in my hand and the original drawing on my arm. Tattoo artist Dicky Magoo immediately understood my vision. "It has to be what is drawn on my arm, because that is an Eric Carle original, but it has to look just like the caterpillar on the book," I kept telling him. I decided against the permanent signature, the drawing was more than enough—and Dicky's rendering phenomenal. My very own Very Hungry Caterpillar has been recognized the world over—from a little girl in Spain to a barista at my neighborhood Starbucks.

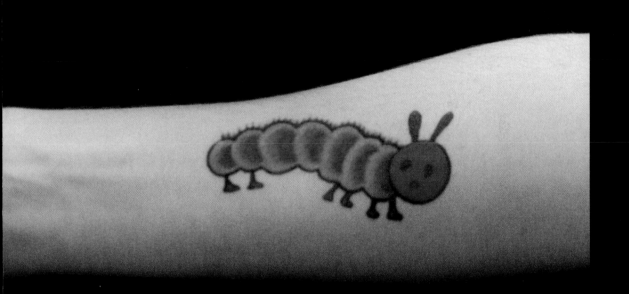

Anonymous at the Associated Writing Programs Conference, 2010
Denver, Colorado

ILLUSTRATION FROM *THE OBJECT LESSON* BY EDWARD GOREY

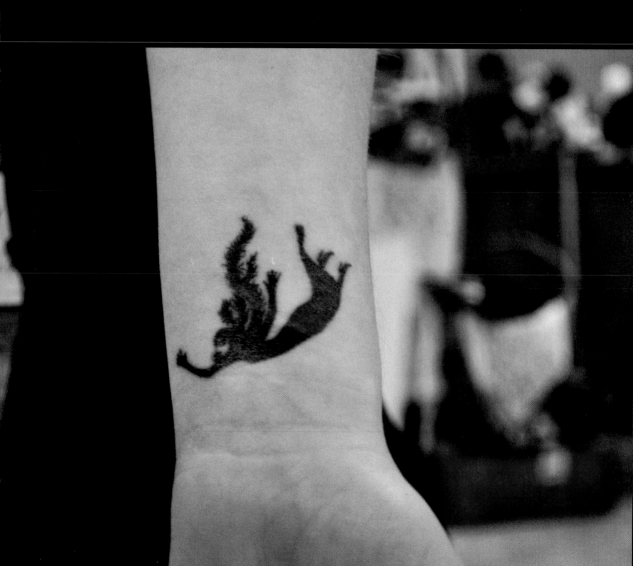

The story goes that this phrase was shouted at young Ray Bradbury by a magician named Mr. Electrico at a carnival in 1932. Each night at the end of his show this magician would be "electrocuted" in front of the crowd and, using a sword, would knight all the children on the front row. In Bradbury's own words: "When he reached me, he pointed his sword at my head and touched my brow. The electricity rushed down the sword, inside my skull, made my hair stand up and sparks fly out of my ears. He then shouted at me, 'Live forever!' I thought that was a wonderful idea, but how did you do it?"

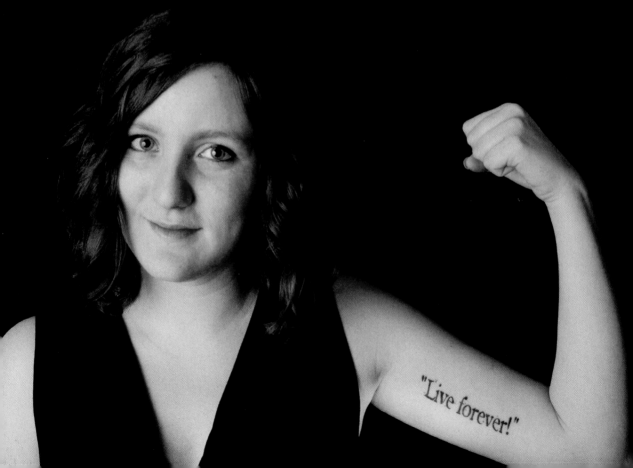

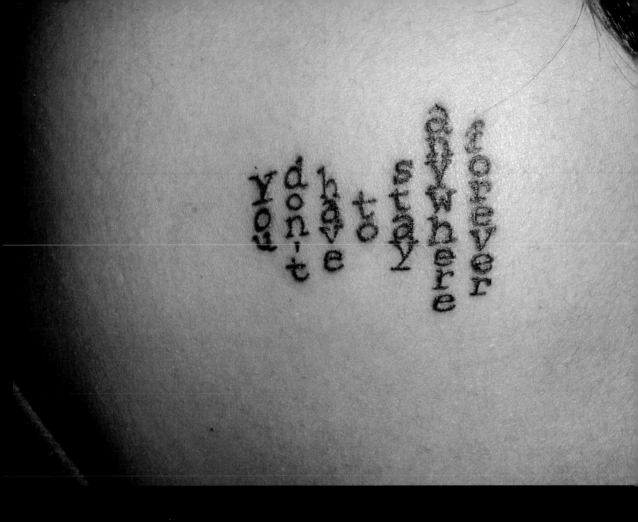

Preeti Chhibber
Brooklyn, New York

LINE FROM *THE SANDMAN* BY NEIL GAIMAN

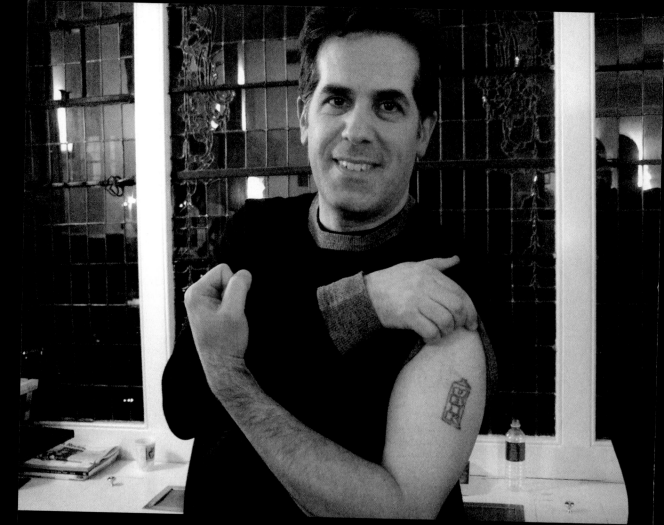

Jonathan Lethem
Brooklyn, New York

UBIK BY PHILIP K. DICK

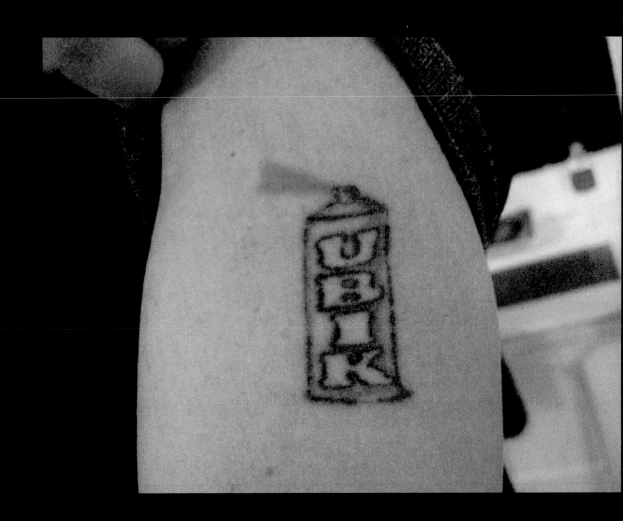

Michael Isenberg
New York, New York

COMICS CODE AUTHORITY SEAL OF APPROVAL

The Comics Code was adopted in 1954, following Senate subcommittee hearings that placed the blame for juvenile delinquency on violent comic books. The strict censorship of the code kept comics "kid-friendly" and dumbed down for decades, and is ultimately responsible for the negative cultural stereotype around comics that persisted for a generation—namely that comics were a subliterate, immature media suitable only for children. The CCA lost its power over the industry when distribution methods changed in the seventies and eighties, with the creation of specialty comic book stores, but the stigma caused by decades of censorship lived on for years.

During college I spent a semester volunteering at the Comic Book Legal Defense Fund, which protects the First Amendments rights of comic book creators, publishers, and retailers, and afterward spent a few years working in the comics industry for *Heavy Metal* magazine, Top Shelf Comics, Marvel Comics, and Web-comics merchandiser Topatoco.com. These days it isn't terribly controversial to say that the comic-book form is capable of great literature. But that wasn't always the case. This seal of approval was in essence a big "censored" stamp that kept an entire medium from realizing its potential. Censorship is the enemy of literature; I see no greater proof of this than in the history of the Comics Code.

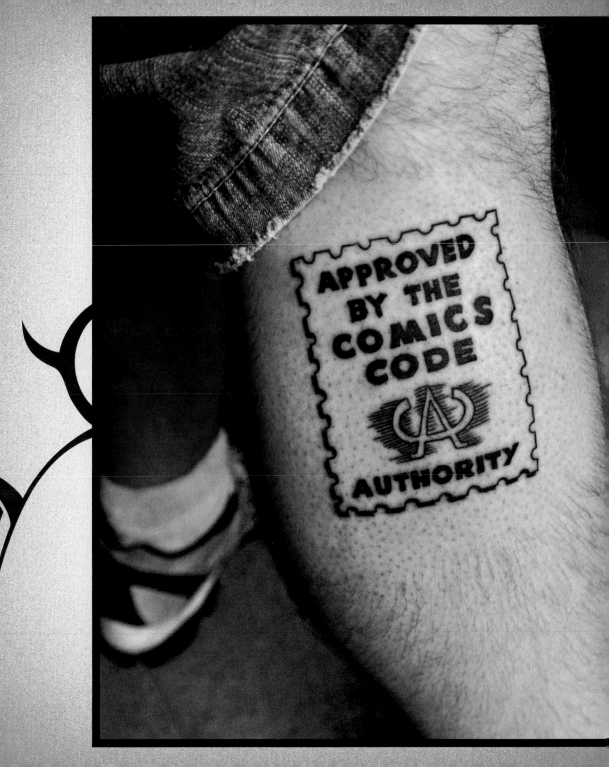

Jeff T. Johnson
Brooklyn New York

IGNATZ MOUSE

George Herriman's comic strip *Krazy Kat* (serialized in U.S. newspapers from 1913 to 1944) hit me like a brick in the back of the head. I first became aware of it when a friend turned my attention to Jay Cantor's novel of the same name. The book was a disappointment, but the comic strips were a revelation. They focus on a bizarre love triangle between a gender-ambiguous cat in love with a hetero-normative family-man mouse who is irked by Krazy's advances, and a police dog (Officer Bull Pupp) who protects and serves Krazy. Ignatz Mouse is preoccupied with tossing bricks and bon mots ("GOOD HUNTING") at Krazy, and Officer Pupp dutifully incarcerates Ignatz in a jailhouse made of bricks. Ignatz slides out a brick, recidivist device in hand, and the cycle repeats. Oh, and Krazy takes the brick-throwing as a sign of affection, so the birdies circling Krazy's head chase hearts. This drama is rendered in a phonetic dialect of Herriman's creation, so the affair gains complexity in the play of language. As Krazy puts it: "AH-H-L'IL AINJIL 'IN MY HOUR OF MELLIN-KOLLY HE SOOTHES ME WITH A BRICK'—MISSIL OF LOVE, AND IFFECTION—"

Recently, a friend asked if I identify with Ignatz or Krazy. I think Krazy is closer to my head, though Ignatz is in my heart. Seeing Ignatz on my arm since Easter 2007—when another friend, tattoo artist Ross Kennedy, drilled the image onto my skin—is like having Krazy stamped on my brain. Ignatz could be suspended in the act of putting one on Krazy, but I also think of the brick as an idea moving ever toward my hand. The image is a tracing from the strip, which was then pressed onto my arm and traced with the tattoo gun. Ross reversed the word "ZIP" but did not reverse the image, so Ignatz appears to be left-handed, as am I. The plot thickens.

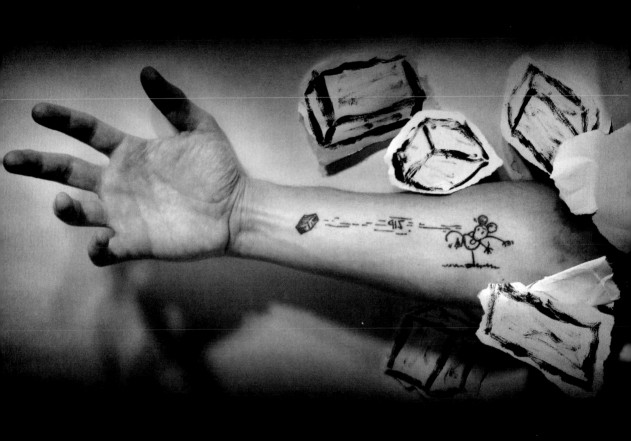

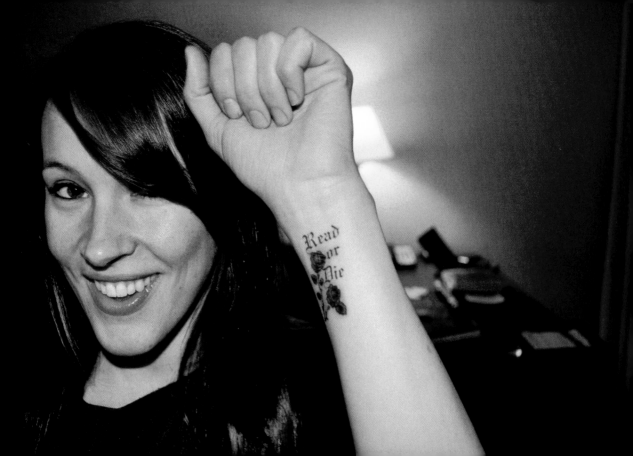

Ben Rubinstein
New York, New York

LINES FROM "ASPARAGUS" BY MARGARET ATWOOD

Messy love is better than none,
I guess. I'm no authority
on sane living.

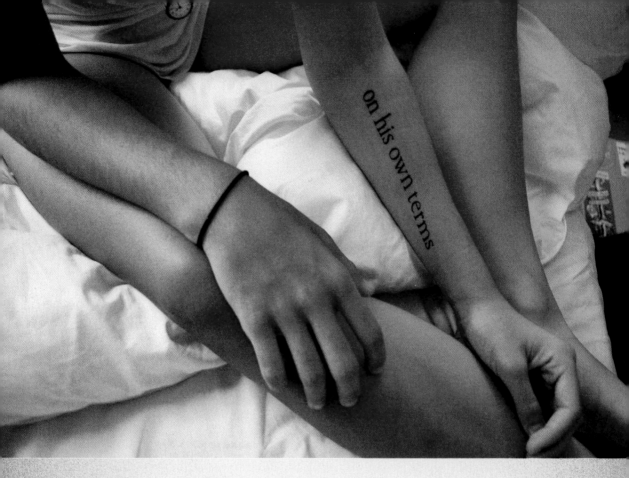

Faye Orlove
Boston, Mass*achusetts*

FRAGMENT FROM *FRANNY & ZOOEY* BY J. D. SALINGER

The full quote from Salinger is, "An artist's only concern is to shoot for some kind of perfection, and on his own terms, not anyone else's." The book centers around the ideas of humanity and respect. The quote itself encourages me to pursue my passion for creating films and expressing myself through art. The tattoo, though, is a constant reminder that I should always remain open-minded and be kind to all people because we are all human.

Faye Orlove
Boston, Massachusetts

"NON SUM QUALIS ERAM," FROM *HOUSE OF LEAVES* BY MARK Z. DANIELEWSKI

The actual quote from the book is "Known some call is air am," which phonetically resembles the latin phrase "Non sum qualis eram." Translated into English, the words mean, "I am not what I once was."

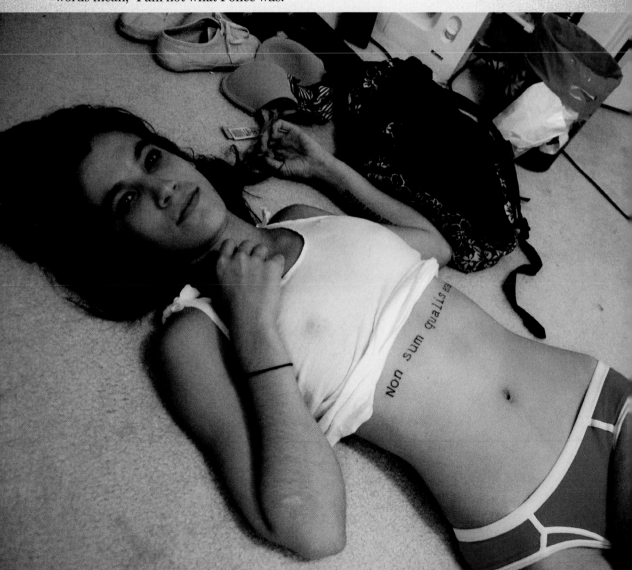

Brighton, England

PASSAGES FROM *NEUROMANCER* BY WILLIAM GIBSON

My tattoo comprises parts of three pages from William Gibson's *Neuromancer,* torn up and then applied at random on different areas of the arm. This makes photographing it quite tricky, because it sprawls and twists around the limb. The concept for my two sleeves is to embody chaos and precision simultaneously, hence the precise writing, but with all meaning of it destroyed and recreated by refusing to allow any full sentences or phrases to appear, and the feel of the book reflected this.

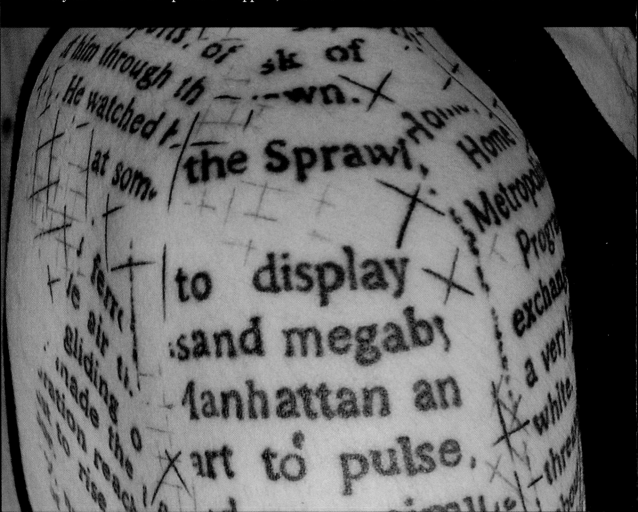

Klara Vybíhalová
Brno, Czech Republic

FIRST STANZA OF "AUGURIES OF INNOCENCE" BY WILLIAM BLAKE

Sandra Willie
Mannheim, Germany

COLLAGE OF ALL THE COVERS OF STEPHANIE
MEYER'S *TWILIGHT* NOVELS

I'm a twenty-seven-year-old mother of three. My husband is a Military Police Officer in the U.S. Army and we are currently stationed in Mannheim, Germany. My tattoos are inspired by the *Twilight* saga. Its currently a three-quarter sleeve, and I plan to be completely sleeved out once it's finished! The tattoo is a combination of all four book covers (*Twilight, New Moon, Eclipse, and Breaking Dawn*). The tattoo on the inside of my arm represents Jacob, in werewolf form, standing on the cliff in La Push, howling at the moon, with a vampire's face hidden in the moon. On the top of my shoulder is the word "Believe" tattooed in Edward Cullen's handwriting.

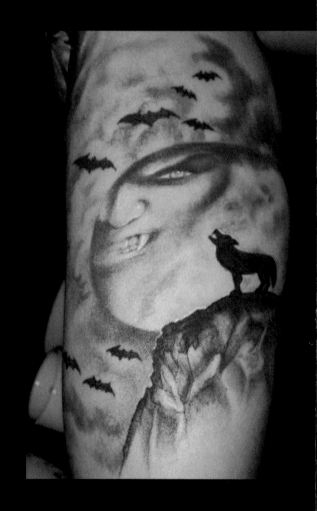

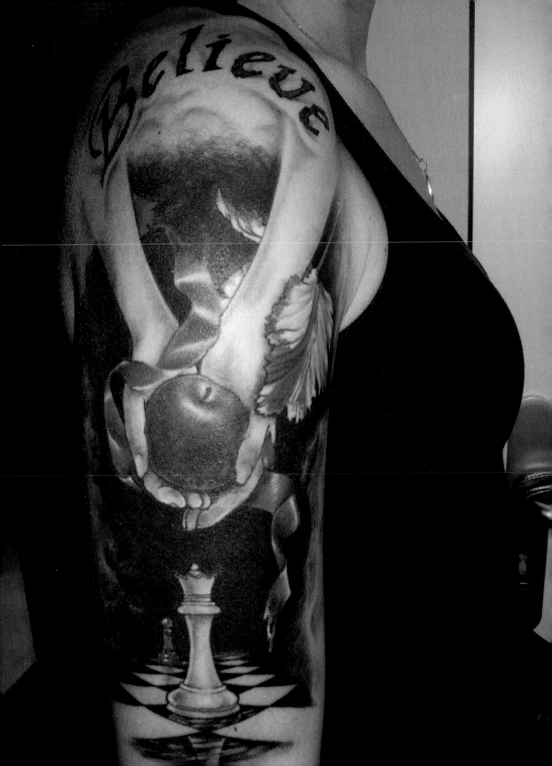

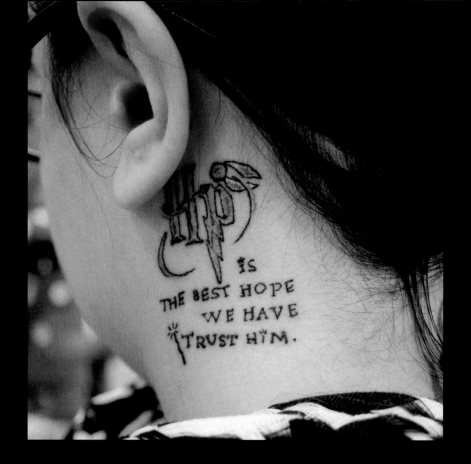

Mandy Porto
Cachoeirinha, Rio Grande do Sul, Brazil

"HP IS THE BEST HOPE WE HAVE," FROM THE HARRY POTTER SERIES
BY J. K. ROWLING

I decided to make them bcz harry potter and twilight are forever, everyone will know the story no matter what, and i just wanted that piece with me always, bcz these 2 series changed my life for good and im a happier person bcz of them ;) Ive known harry potter for almost 10 years now and the passion never goes away, in fact is growing more and more. Books have a magic that other things don't have! Books are unique and amazing and they deserve to be remembered, loved and respected, bcz books are forever!

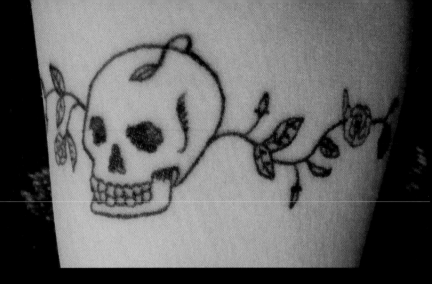

THIMBLE AND HARRY POTTER "PATRONUS"

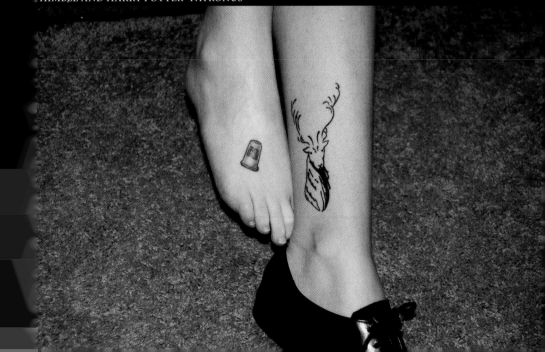

Edinburgh, Scotland

"NOX/LUMOS"—SPELLS FROM THE HARRY POTTER SERIES BY J. K. ROWLING

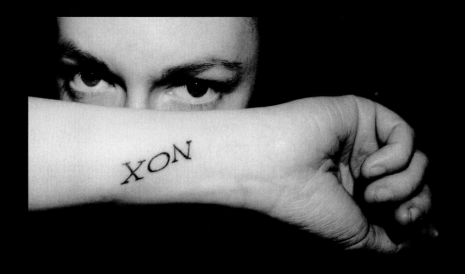

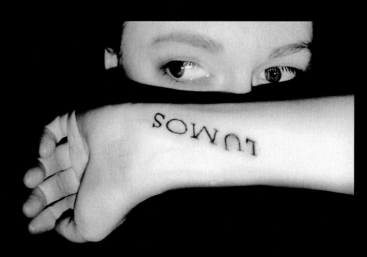

The windows of
my soul I throw
Wide open to the sun.

Liza Umayam
Manila, Philippines

TWO LINES FROM "MY PSALM" BY JOHN GREENLEAF WHITTIER

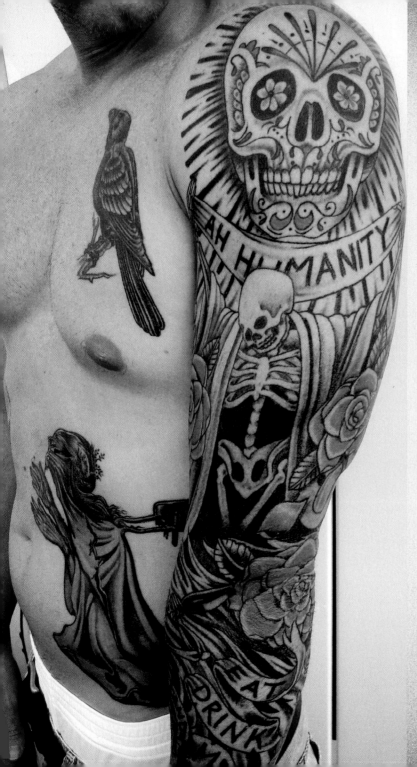

**Alec Bryan
Ogden, Utah**

LAST LINE OF "BARTLEBY, THE
SCRIVENER" BY HERMAN MEL-
VILLE WITH GUSTAVE DORÉ
ILLUSTRATION FOR THE BOOK
OF EZEKIEL

My half-sleeve has Gustave
Doré's depiction of the
vision of the bones from
Ezekiel 37 on the arm, and
Ezekiel is holding a banner
that says "Ah humanity,"
which is the last line from
Melville's short story "Bar-
tleby, the Scrivener." The
gist of it is that humanity
has everything it needs to
be happy, yet we will end
up slaughtering the entire
race.

It is the image
of the ungraspable
phantom of life;
and this is the
key to it all.

Oden Connolly
Berkeley, California

LINE FROM *MOBY-DICK* BY HERMAN MELVILLE

Drew Toal
Brooklyn, New York

ROCKWELL KENT ILLUSTRATION FROM *MOBY-DICK* BY HERMAN MELVILLE

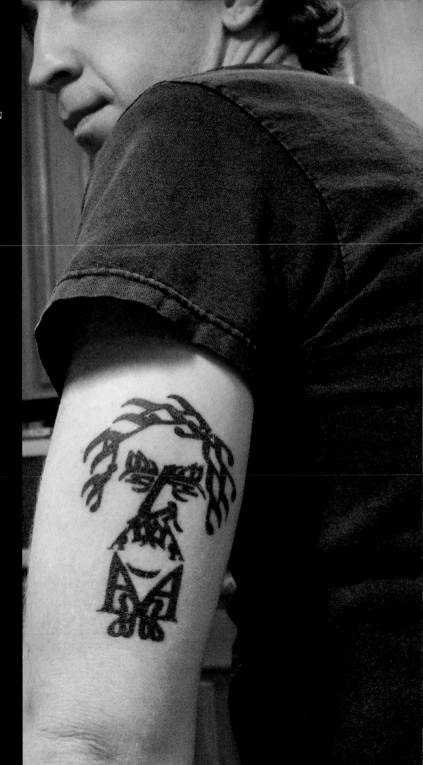

Drew Toal
Brooklyn, New York

CARICATURE OF MARK TWAIN

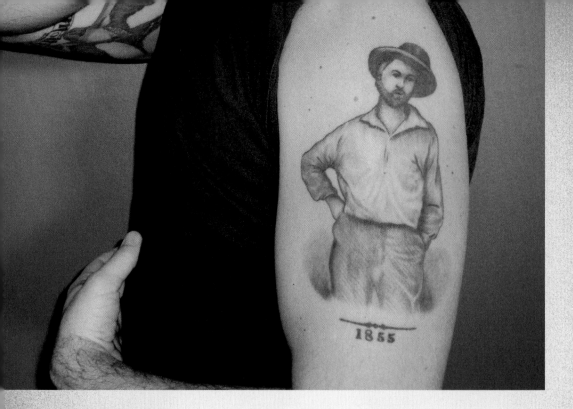

Bryan Waterman
Brooklyn, New York

PORTRAIT OF YOUNG WALT WHITMAN

The tattoo, obviously, is the image Walt Whitman used as the frontispiece to the first edition of *Leaves of Grass*. It was a gift from a friend—the owner of my neighborhood bar—on the publication of my first book (which coincided with my getting tenure at NYU). I'd been planning on using this image for a while. It has a reference, first of all, to my vocation: I research and teach early American literature, and this is about as canonical as American literary iconography gets. But it's also related to a sense of place, to where I live: it's the quintessential image of the self-made New Yorker, the newspaperman and former schoolteacher dressing up like one of the roughs. I think of Whitman as the patron saint of lower Manhattan (Brooklyn, too); when I see the image I think to myself: "Take off your hat to nothing known or unknown, or to any man or number of men."

Craig Rebele
San Francisco, California

PORTRAIT OF OLD WALT WHITMAN

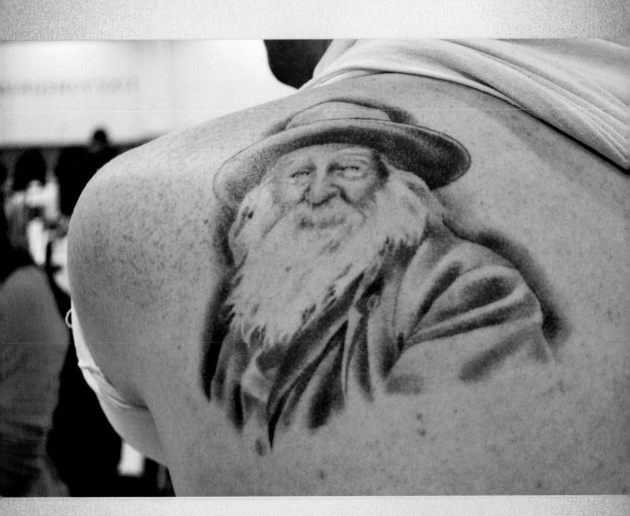

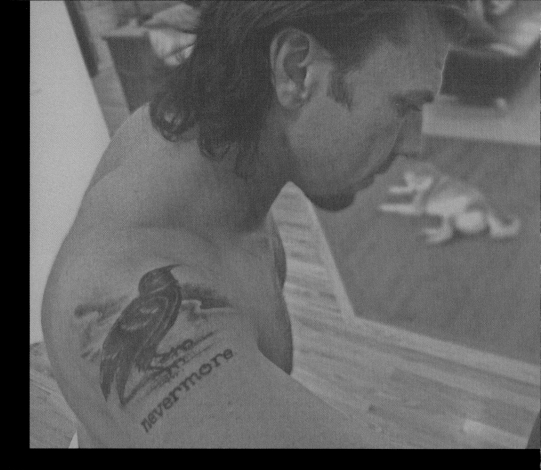

Carter Wilson
Erie, Colorado

"NEVERMORE," FROM "THE RAVEN" BY EDGAR ALLAN POE

I'm a thriller writer by night and a hotel consultant by day. I've completed four novels and am halfway through a fifth, and I have an agent trying to get me sold. I'm very dedicated to my writing, and the tattoo (my one and only) is a reminder to myself to pursue my writing and never give up. My tastes gravitate toward the dark, and I've always had a fondness for Poe, so I came up with this image for my shoulder.

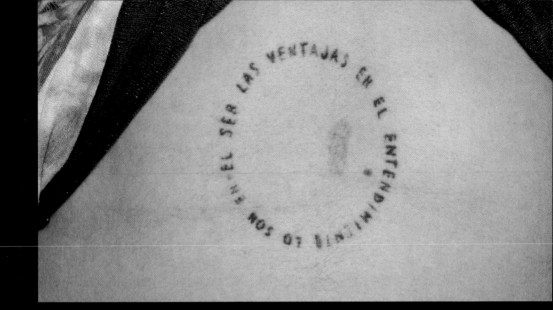

Leigh Bush
Bloomington, Indiana

LINE FROM *LA RESPUESTA* BY SOR JUANA INÉS DE LA CRUZ

This tattoo is from Sor Juana Inés de la Cruz, a genius, voracious scholar and one of the first feminists of the New World. After reading her work *La Respuesta* and falling in love with the strength and intelligence of this woman who lived in such an oppressive era, I did exactly what my parents told me I could never do (if I wanted any money for college from them) and got her words tattooed in a circle on my abdomen. It is in Old Spanish, so the translation is a little rough but essentially it says: "The advantages of understanding (or, knowledge) are those of being." That is, the more you understand/know the better/fuller/more complete you are and the more completely you live. Also, the feelings behind this tattoo are closely linked to my mentor and one of the most amazing and influential women I've ever met, Griselda (a teacher and friend of mine). She committed suicide about three months after she gave me the strength to go through with this, my first tattoo. It's been almost five years and I'm glad to have it (and her memory) forever.

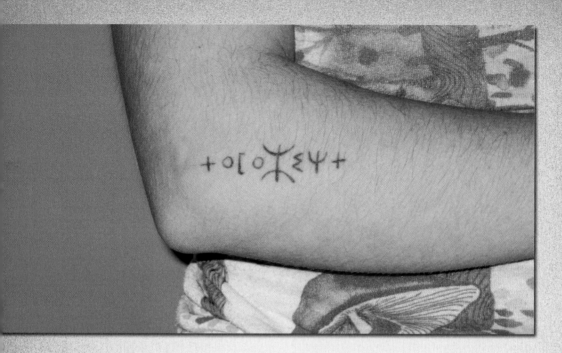

Leigh Bush
Bloomington, Indiana

BERBER SAYING

This is in the language of the Amazigh people (translated as "free people"). In Morocco the Amazigh are known as Berbers, and their written language is known as Tifinagh. The symbols are thought to have come from the Phoenician alphabet and to have only recently developed. After spending some time in Morocco, I found their central idea of Tamazight, or "I am free" (also the name of the language), to be both capturing and an ideal mantra to try and live out. Translated, it literally says just that: "I am free." It is significant to my life because I am all manners of privileged and I want to use that freedom to its highest potential. The symbols themselves are also aesthetically gorgeous as script. For this reason I would not let my tattoo artist embellish the letters at all, but requested the brightest blue I could get for the coloring.

Leigh Bush
Bloomington, Indiana

"IMP OF THE PERVERSE"

Like many people, I was a cutter. For me, Poe's short story "The Imp of the Perverse" harkens to this undeniable perversity, that is the unconquerable force that impels us to walk toward the precipice.

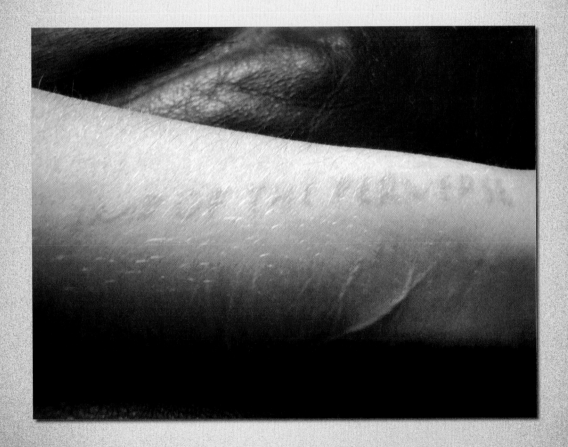

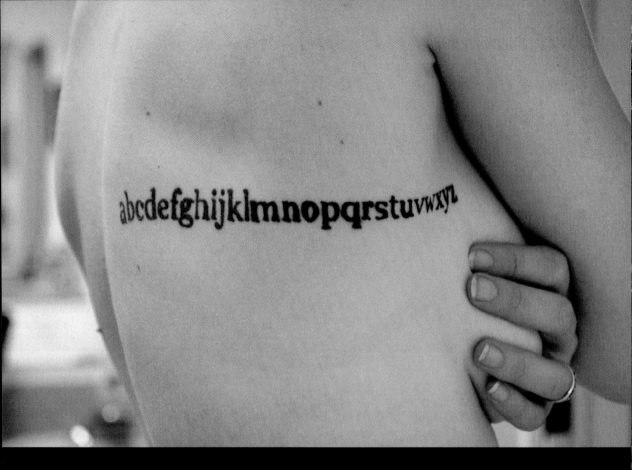

Elizabeth Wisker °
Brooklyn, New York

ALPHABET

I studied literature and wanted a tattoo that represented its place in my life and the importance of language to me. There was no way I could have decided on one word, phrase, or quotation, so I chose to use the basic elements that create what I care about most: the alphabet. I am currently studying library and information sciences, and the tattoo's presence now stands for that love in my life, as well.

Matthew Rohrer and Rebecca Wolff
Denver, Colorado

ALPHABETS IN LOWER AND UPPER CASE

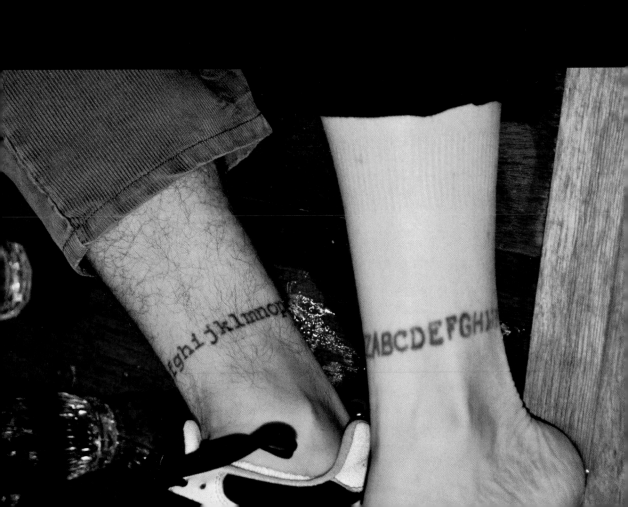

Danielle
Indianapolis, Indiana

DEWEY DECIMAL NUMBER FOR POETRY

I work at the reference desk of a library, and I'm a poet, so it seemed appropriate. I love that this number never changes. I love the nature of libraries; the exchange of information and inspiration. I love poetry. I got the tattoo for my twenty-fourth birthday.

I got it to celebrate finishing my master's degree in library and information studies in August 2008. I had worked on the degree for three years and wanted a tattoo to commemorate the occasion. I went through several ideas before settling on the skull and crossed books. All my other tattoos are blackwork, and I wanted something colorful, lighthearted, and fun to contrast. It's by far my favorite tattoo both for the design and because I associate it with a hard-won accomplishment and a profession of which I'm proud.

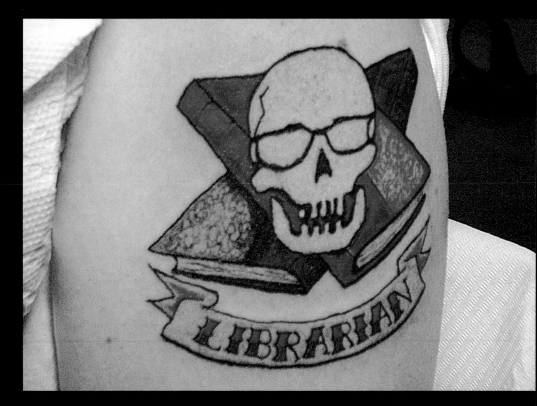

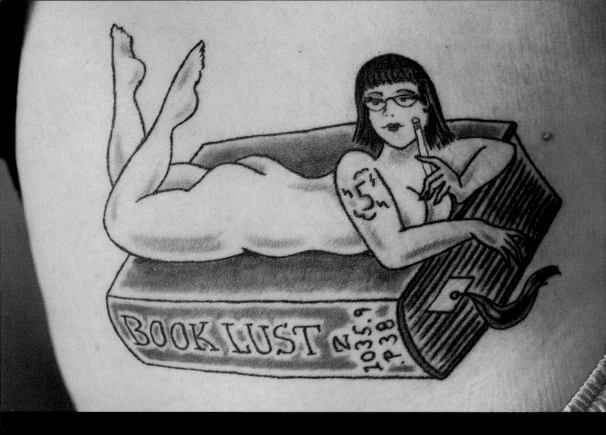

Heidi

"BOOK LUST"

For my thirteenth tattoo and my thirty-sixth birthday, I wanted to get a sexy librarian pin-up. After perusing the available book-related pin-ups, I realized that there was no reason why I could not be the model for that pin-up. The book on the tattoo is *Book Lust*, written by famous librarian Nancy Pearl. The book is about loving books, and that call number is representative of a Library of Congress call number, the kind most often used in academic libraries.

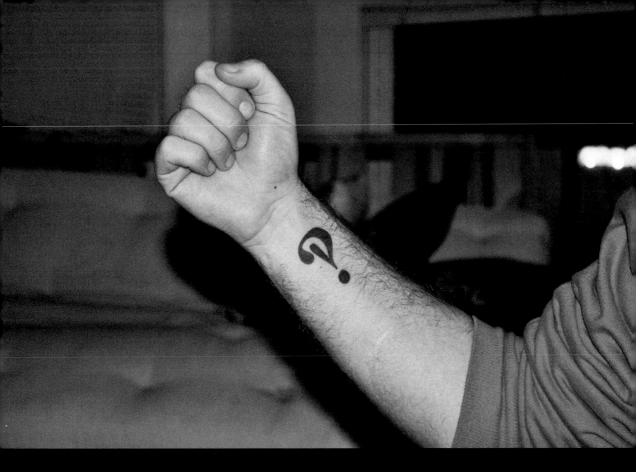

Leathan Graves-Highsmith
Portland, Oregon

"INTERROBANG"

121

Evan Carver
Denver, Colorado

SEMICOLON

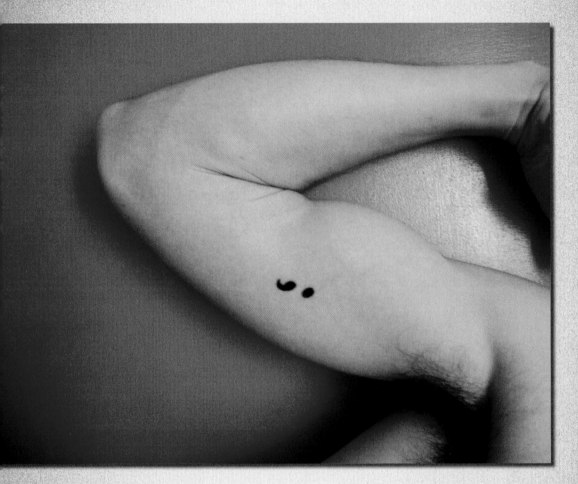

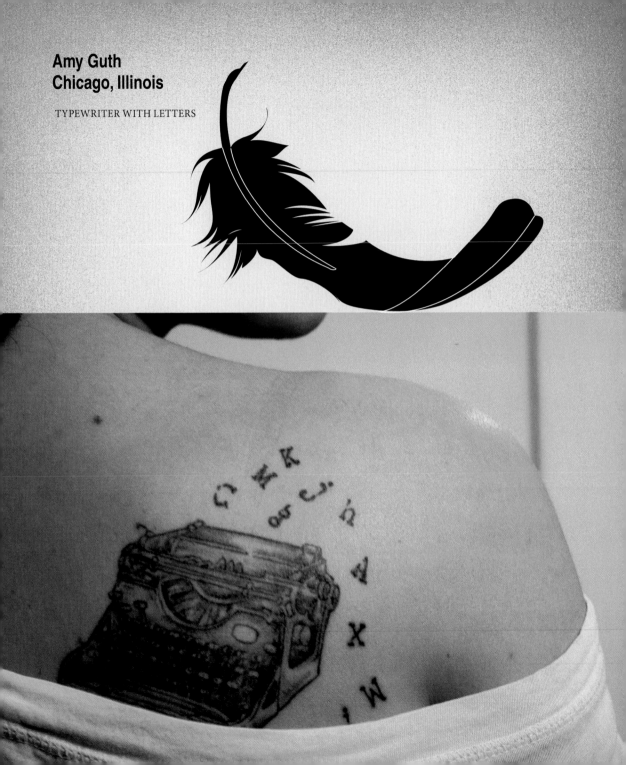

Amy Guth
Chicago, Illinois

TYPEWRITER WITH LETTERS

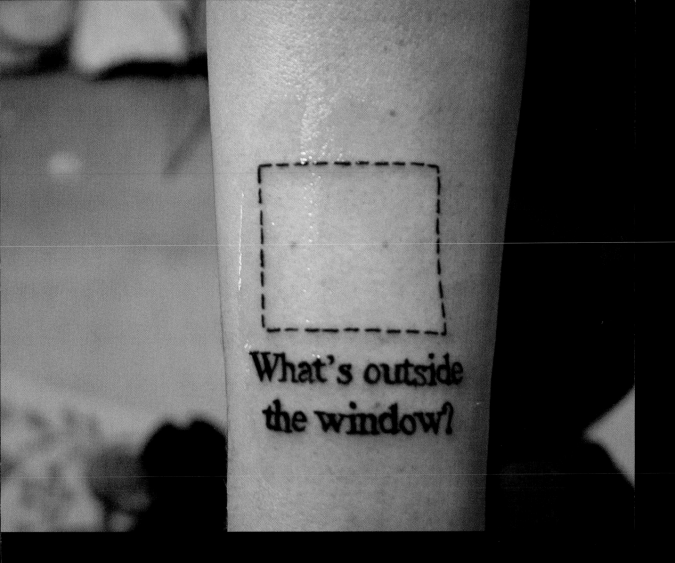

Robert Alan Wendeborn

"WHAT'S OUTSIDE THE WINDOW?" FROM *THE SAVAGE DETECTIVES* BY ROBERTO BOLAÑO

I got this tattoo because I think it's a great end to a book that leaves a lot of possibility and creativity in the hands of the reader. I get to decide what's out-side the window. I get to decide what happens to the poets.

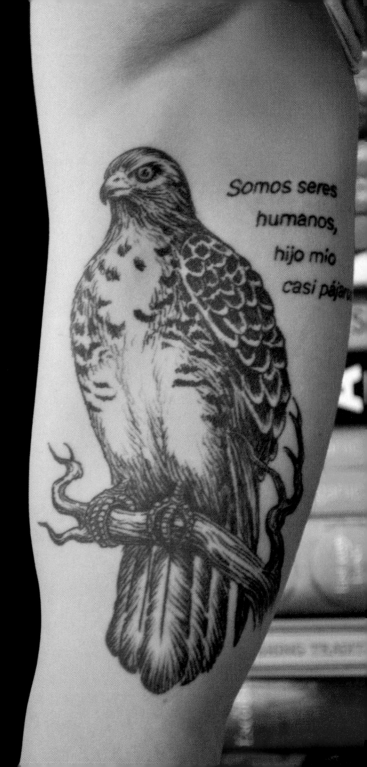

Adam Wilson
Brooklyn, New York

LINES FROM ROBERTO BOLAÑO'S POEM
"GODZILLA IN MEXICO"

The bird in the tattoo is a red-tailed hawk. There is a red-tailed hawk that lives in a tree outside of Dodge Hall, where the Columbia MFA writing program is located. I watched that hawk a lot out the window. One time I saw it swoop down and catch a rat, then slowly kill it with its claws, and eat it. People were taking pictures on their cell phones. Writing students were taking notes and saying they had first dibs on using this scene in a story. In English, the line from the poem is, "We are human beings my son, almost birds."

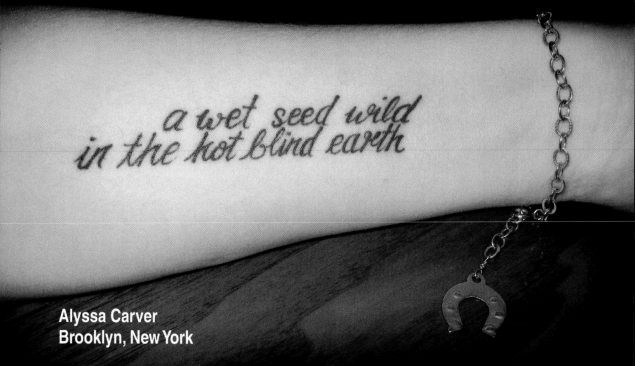

Alyssa Carver
Brooklyn, New York

FRAGMENT FROM *THE SOUND AND THE FURY* BY WILLIAM FAULKNER

I knew it would have to be small, physically, in order to fit where I wanted it. The fragment I chose is just nine short words—but they do so much! This sentence just kills me every time I read it. I love the alliteration and the urgency of wet and wild, the lack of punctuation, and the perfect balance between adjectives and nouns.

Then there's the little transposition that elevates the whole thing to the level of poetry: he takes a pair of perfectly symmetrical phrases and turns one askew. It's not a wet, wild seed but a wet seed wild, and suddenly the cadence of the whole sentence is more musical and beautiful. The way I have the phrase broken into two lines accentuates the simplicity and asymmetry of this structure because the nouns and adjectives line up on top of each other.

When I brought this idea to Mehai at Fineline Tattoo in New York City, I knew that I wanted the writing to line up with the veins under the skin. I felt

instinctively that it should be handwritten, but I knew it couldn't be my own handwriting, and I couldn't find any samples that I liked. So I asked Mehai to just write it out by hand in basic cursive, nothing too stylized. And that was it. I wanted the words to indicate the vital force at work beneath them. Life is insistent even when we can't see it—even when we don't want it. Even when things seem dead, there is something at work in the darkness, some potential germinating, enfolded, deeply asleep. Something in us wants to live, knows only how to live, regardless of desire or consequence.

Kendra
Winthrop Massachusetts

FRAGMENT FROM *TO THE LIGHTHOUSE* BY VIRGINIA WOOLF

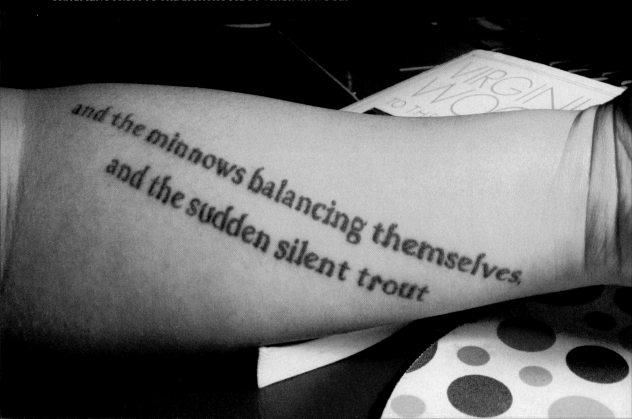

Shawna Lipton
Milwaukee, Wisconsin

A MADELEINE FROM *IN SEARCH OF
LOST TIME* BY MARCEL PROUST

I got this tattoo to commemo-
rate the year I spent reading *In
Search of Lost Time.*

It was a life-changing ex-
perience.

I'm always shocked at how few people make themselves into a lifelong monument to their favorite prose or verse.

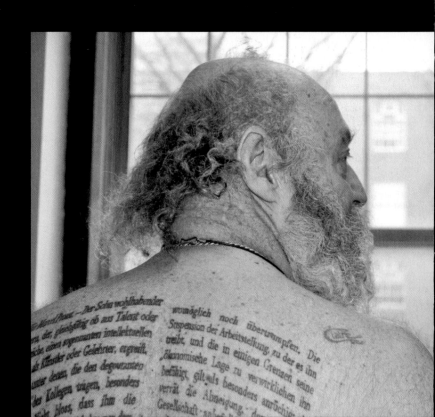

Für Marcel Proust. — *Der Sohn wohlhabender Eltern, der, gleichgültig ob aus Talent oder Schwäche, einen sogenannten intellektuellen Beruf, als Künstler oder Gelehrter, ergreift, hat es unter denen, die den degoutanten Namen des Kollegen tragen, besonders schwer. Nicht bloss, dass ihm die Unabhängigkeit geneidet wird, dass man dem Ernst seiner Absicht misstraut und in ihm einen heimlichen Abgesandten der etablierten Mächte vermutet. Solches Misstrauen trägt zwar von Ressentiment, würde aber meist seine Bestätigung finden. Jedoch die eigentlichen Widerstände liegen anderswo. Die Beschäftigung mit geistigen Dingen ist mittlerweile selber 'praktisch', zu einem Geschäft mit strenger Arbeitsteilung, mit Branchen und numerus clausus geworden. Der materiell Unabhängige, der sie aus Widerwillen gegen die Schmach des Geldverdienens wählt, ist nicht geneigt, das anzuerkennen. Dafür wird er bestraft. Er ist kein 'professional', rangiert in der Hierarchie der Konkurrenten als Dilettant, gleichgültig wieviel er sachlich versteht, und muss, wenn er Karriere machen will, den stupiden Fachmann an entschlossener Borniertheit*

womöglich noch übertrumpfen. Die Suspension der Arbeitsteilung, zu der es ihn treibt, und die in einigen Grenzen seine ökonomische Lage zu verwirklichen ihn befähigt gilt, als besonders anrüchig: sie verrät die Abneigung, den von der Gesellschaft anbefohlenen Betrieb zu sanktionieren, und die auftrumpfende Kompetenz lässt solche Idiosynkrasien nicht zu. Die Departmentalisierung des Geistes ist ein Mittel, diesen dort abzuschaffen, wo er nicht ex officio, im Auftrag betrieben wird. Es tut seine Dienste um so zuverlässiger, als steht derjenige, der die Arbeitsteilung kündigt — wäre es auch nur, indem seine Arbeit ihm Lust bereitet —, nach deren eigenem Mass Blössen sich gibt, die von den Momenten seiner Überlegenheit untrennbar sind. So ist für die Ordnung gesorgt: die einen müssen mitmachen, weil sie sonst nicht leben können, und die sonst leben könnten, werden draussen gehalten, weil sie nicht mitmachen wollen. Es ist, als rächte sich die Welt an dem, den die unabhängigen Intellektuellen desertiert sind, indem zwanghaft ihre Forderungen dort sich durchsetzen, wo der Deserteur Zuflucht sucht.

Alejandra
Capital Federal, Argentina

HAIKU

The tattoo on my left shoulder and arm is a *sumi-e* (Japanese ink) featuring a cherry blossom (unknown artist) and a haiku from Kobayashi Issa: "ku no shaba ya sakura ga sakeba saita tote." I have found two different interpretations of its meaning: my favorite one is "world of grief and pain, cherries bloom, even then." The other one is quite the opposite: "world of grief and pain, and the blooming of cherries adds to it." I love the first one, because I tend to be a pessimistic person and I like to focus on every little nice thing to counteract it. Also, five years ago I got very sick and depressed (still in recovery), and when the worst part was over, I started to find the world a lot "brighter" than before. I started living more intensely, enjoying things I didn't even notice until then. This tattoo works for me as a reminder of all the beauty that surrounds me, even if I'm not able to see it, and of the fact that bad moments are necessary to learn to really appreciate the good ones.

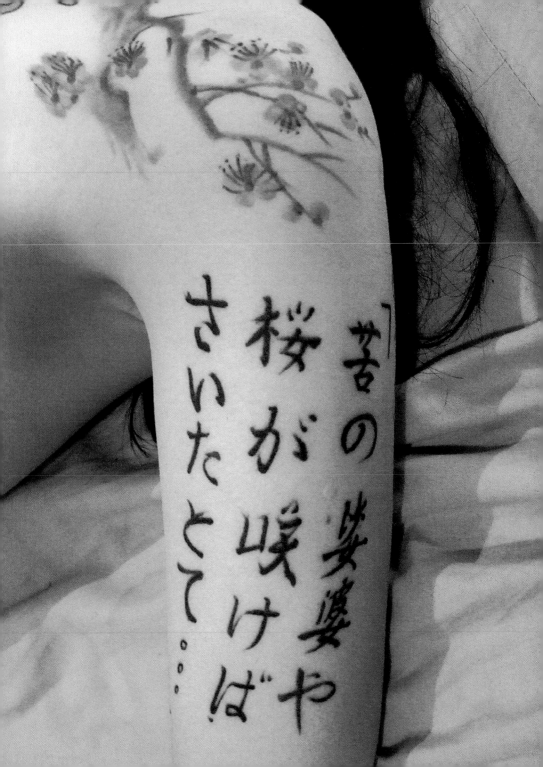

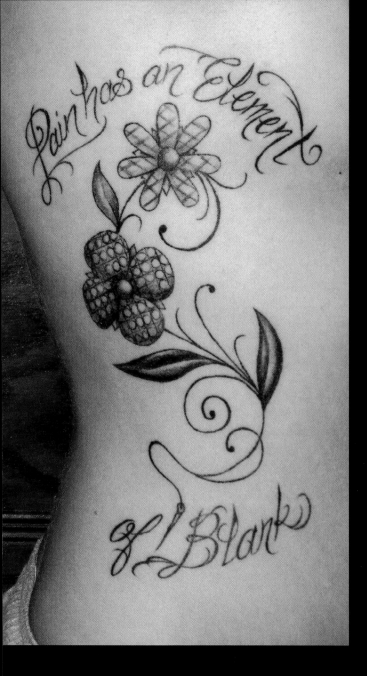

Nicole
Hawthorne, New Jersey

FIRST LINE OF A POEM BY EMILY
DICKINSON

I got this tattoo shortly after be-
ing diagnosed with fibromyalgia, a
chronic pain condition. Although
I think it would have been appli-
cable even without that diagnosis.
I was diagnosed with a hereditary
blood disorder known as hereditary
spherocytosis at birth and had my
spleen removed as a result of that
condition when I was six. Because
of that, my immune system was
weakened and I spent my childhood
in and out of the hospital for various
infections. I also live with chronic
depression and anxiety.

It is sometimes awkward
when I tell people what my tattoo
says. Pain and illness are a taboo
subject for most, but to me there is
something reassuring about how
Dickinson points out the limita-
tions of pain while also expressing
its power. It was an "aha" moment

for me, realizing somebody else gets it! Yes, pain might have no future but itself, but at the same time there will always be new periods of pain. This is an eloquent description of living with chronic illness, because when you have good times often you are preparing for the bad to creep back in: it's always present in the back of your mind. And because my illnesses can be classified as "invisible" (I look normal and healthy) the word "blank" stood out heavily in my mind. Pain is nothing, but it is also everything. It is numbing, and often hidden, yet all encompassing. Pain is not good or bad, it just is. Plus the tattoo gives me an excuse to explain that I have fibromyalgia, mental health issues, or no spleen, which is a conversation I always end up having to have at some point anyway.

The Complete Poem by Emily Dickinson

Pain has an element of blank;
It cannot recollect
When it began, or if there was
A time when it was not.

It has no future but itself,
Its infinite realms contain
Its past,
enlightened to perceive
New periods of pain.

Stephanie Sabelli
Brooklyn, New York

EXCERPTS FROM SONNETS BY PABLO NERUDA

I got each one of my tattoos when I was going through a depression of some kind or another, mostly unrequited loves and heartbreaks. I never started getting tattoos until I quit drinking; I think it's one of my only ways I can still be rebellious, one of the only vices I still get to enjoy (besides my cigarettes). Even though I'm feeling fuckin' great these days, I still relate to each one and don't regret a thing.

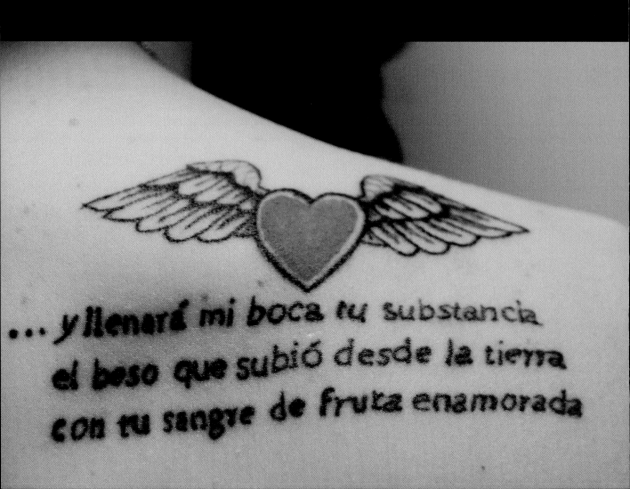

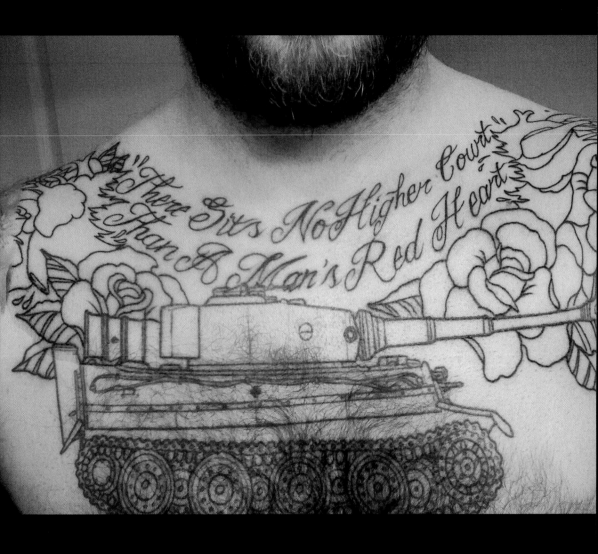

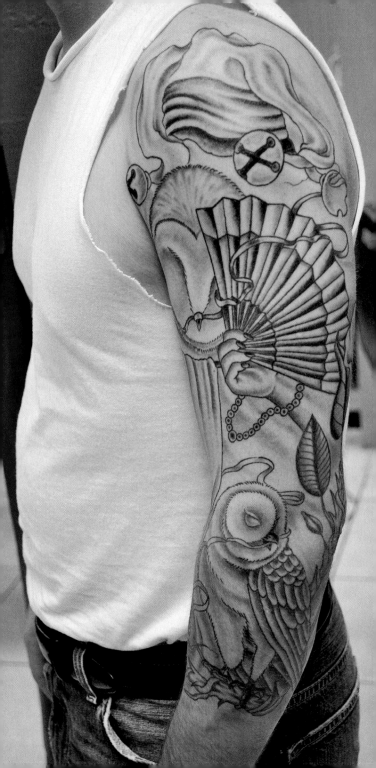

Kyle Koerber
Houston, Texas

ILLUSTRATIONS OF IMAGES FROM "THE CAP AND BELLS" BY W. B. YEATS

I wanted to capture five parts of the poem that were important to me:

1. His offer of his soul (blue garment, when the owls began to call)
2. Her rejection of his soul (shutting the window)
3. His offer of his heart (red garment, when the owls called out no more)
4. Her rejection of his heart (waved it off with her fan)
5. His sacrifice of his life (leaving behind the cap and bells)

 My tattoo is black-and-white so the colors are not there, but the ribbons are each garment. To illustrate 1 and 2, the lowest oil holds the "blue" ribbon, which winds up and is fluttering in front of the closed window. In 3 and 4, the sleeping owl has the "red" ribbon wrapped around his beak, which proceeds around to her extended fan. The fifth is simply the cap and bells at my shoulder. The flowers are calla lilies and were mostly put in for framing/spacing and flow of the tattoo. I think this poem is a wonderful illustration of the sad beauty of unrequited love, and how there can be great meaning in dedicating your life to someone you love, even if they don't return that love.

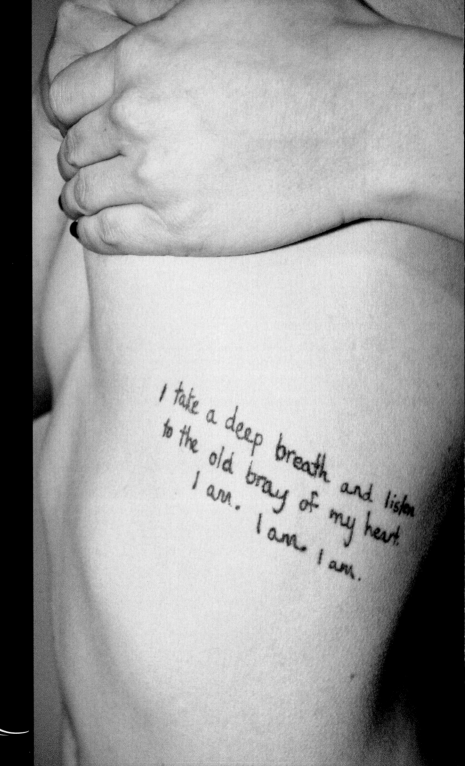

Brit Blalock

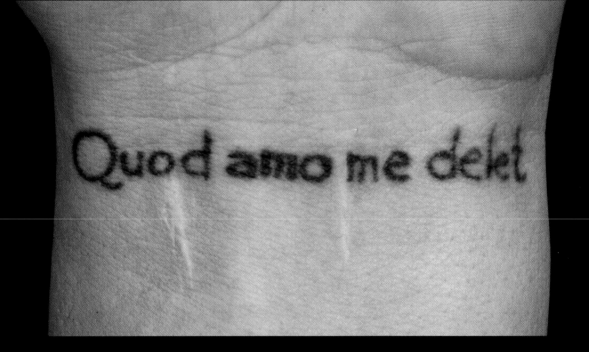

Danielle de Santiago
Aachen, Germany

"QUOD AMO ME DELET"

My tattoo is a quote from an old Latin poem. . . . It reads: *"Quod amo me delet."* The author was a Roman philosopher and the poem is carved into the walls of an old grotto in Italy, where I spent the summer of '96, and somehow I never have forgotten that line.

The meaning is: "What I love destroys me," or "What I love erases me."

Lauren Reed
Morgantown, West Virginia

LINE FROM VIRGIL'S *AENEID*

On my right waist in black script, on the sliver of skin a bikini lies overtop, is a Latin phrase from *The Aeneid*. It translates to, "Someday, perhaps, remembering even this will be a pleasure." To me that could mean one of two things: that life could always become harder, so one should never take anything for granted, or that surviving the rough times only makes the blessed even more appreciated. If you've never had a glass of bad wine, how would you know it if you drank a really great one?

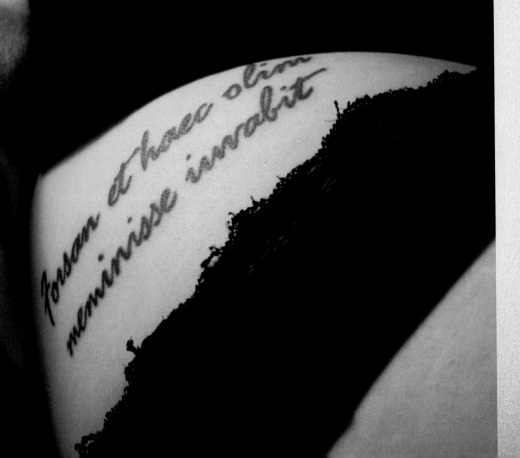

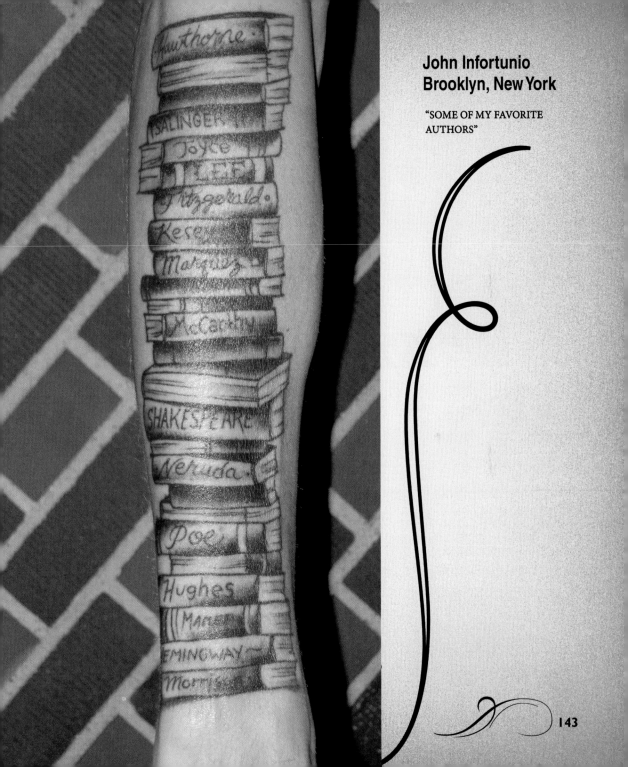

**John Infortunio
Brooklyn, New York**

"SOME OF MY FAVORITE
AUTHORS"

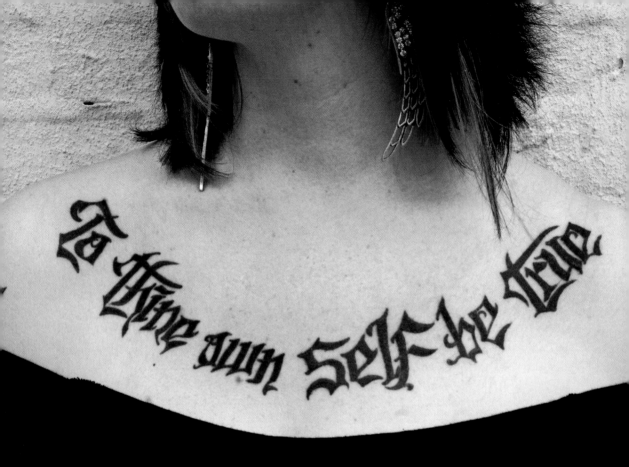

Carrie
New York, New York

LINE FROM *HAMLET* BY WILLIAM SHAKESPEARE

I had the words "To thine own self be true" inscribed backwards on my
chest, so it's the first thing I read every day.

My tree is meant to represent the seasons of life, with knowledge as the root rather than the fruit. Work on this back piece began when I was twenty-nine. I was facing a milestone birthday and I was new to the teaching profession. During that time of change, Shakespeare's words for Hamlet seemed a fitting touchstone.

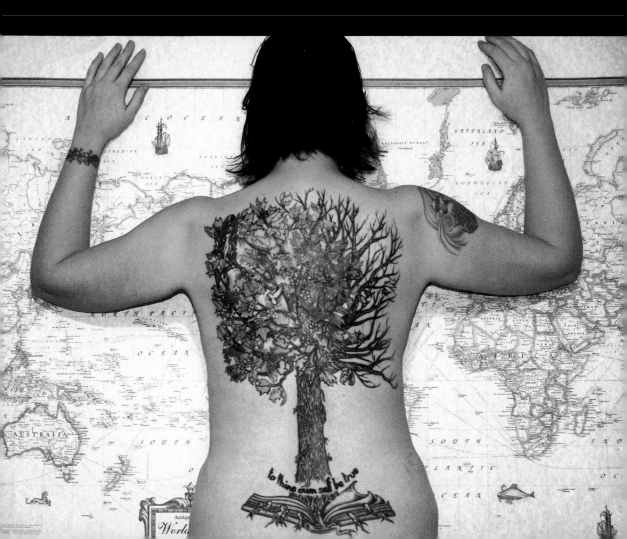

Stephanie Anderson
Brooklyn, New York

THE FIRST WORD OF *BEOWULF* (LEFT) AND A LINE FROM *HAMLET* (RIGHT)

I've been a bookseller since I got my working papers in high school. I started at a Waldenbooks (a store that is now closed, which breaks my heart), worked at the Moravian Book Shop in Bethlehem, Pennsylvania, while in college, and then sort of stumbled into a full-time job at Moravian after I graduated without a clue about what to do. I stayed in indie bookselling, because it's a great job in one of the nicest and smartest professional communities in the country. I've been at WORD Books in Greenpoint, Brooklyn, since last February and moved here for the job.

I got my first tattoo, the alphabet in Zapfino font, when I was eighteen. The "words, words, words" (Hamlet, in response to "What are you reading, my lord?") in American Typewriter was my second—they were both done by Jimmy James in Bethlehem. Third was "to strive, to seek, to find, and not to yield," in Mona Lisa, my twentieth-birthday present to myself. It's the last line of "Ulysses" by Alfred, Lord Tennyson. Fourth was on my right rib cage: "it's pretty, but is it Art?" from "The Conundrum of the Workshops" by Rudyard Kipling (a poem that also sums up the reason I did not pursue an MFA).

The fifth cannot be typed in modern English, because it is Old English and includes a character we don't use anymore, and is the first word of *Beowulf*. It doesn't translate cleanly, but a medievalist at my college agrees that the colloquial is the best way to go with "Hwæt," and said that he would probably best translate it as "yo." Anyway, my mom, who is an author (Laurie Halse Anderson), decided that she wanted it as her first tattoo, because it is a storytelling word—it is the first word of *Beowulf* because it's a word with the connotation of "Hey, y'all, I'm going to tell a story now, so pay attention." I thought this was awesome and so we both got it together. The lettering is from one of the original manuscripts. Inter-

estingly, it has healed very differently on both of us. You'd never guess we got them one after another.

Many people assume that my tattoos, like all modern-day tattoos, are imbued with a tremendous sense of meaning. There seems to be a growing sentiment, probably developed in defense against anti-tattoo sentiment, that a tattoo has to "mean" something: it has to remind one of a dead person, or a hard/nice time in life, or one's life philosophy. Which is, of course, totally legit, and I wouldn't go so far as to say that my tattoos mean nothing. I love having the same tattoo as my mom, and I never would have gotten any of these if they didn't resonate with me in some way. But also, they're pretty. I got them because I like the way they look. I like words and I love typefaces. I like having them with me everywhere I go.

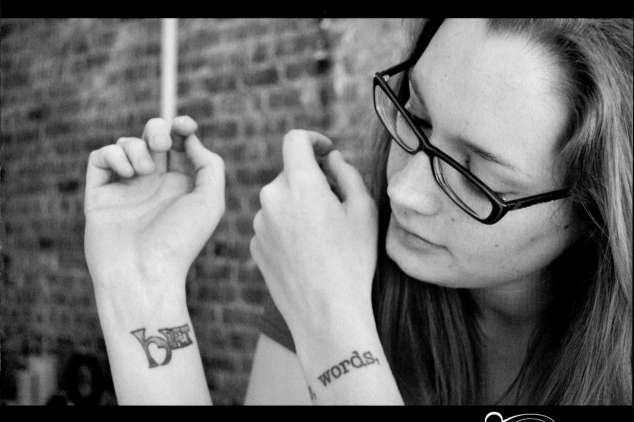

Kristianna Berger
Denver, Colorado

EXCERPTS FROM "DOGFISH"
BY MARY OLIVER

I live. here

Some kind of relaxed and beautiful thing
kept flickering in with the tide...
the dogfish tore open the soft basins of water...
I want to listen
to the enormous waterfalls of the sun...
a few people just trying,
one way or another,

to survive...

And nobody gets out of it, having to
swim through the fires to stay in
this world...
And probably,
if they don't waste time
looking for an easier world.
they can do it.

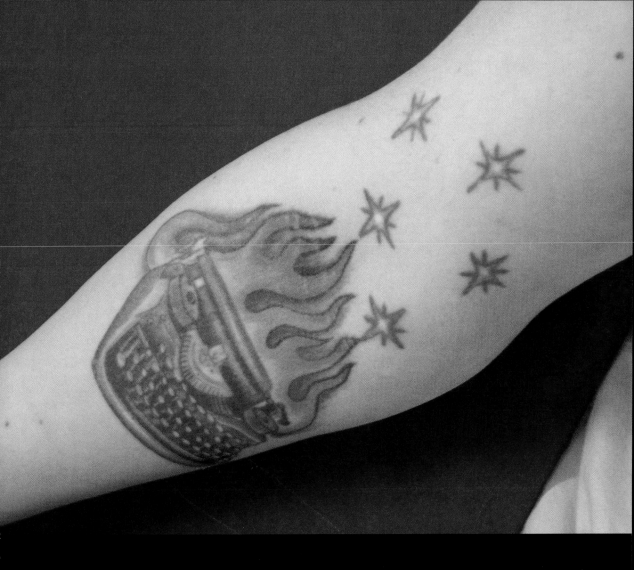

Ellen Moynihan
Brooklyn, New York

FLAMING TYPEWRITER

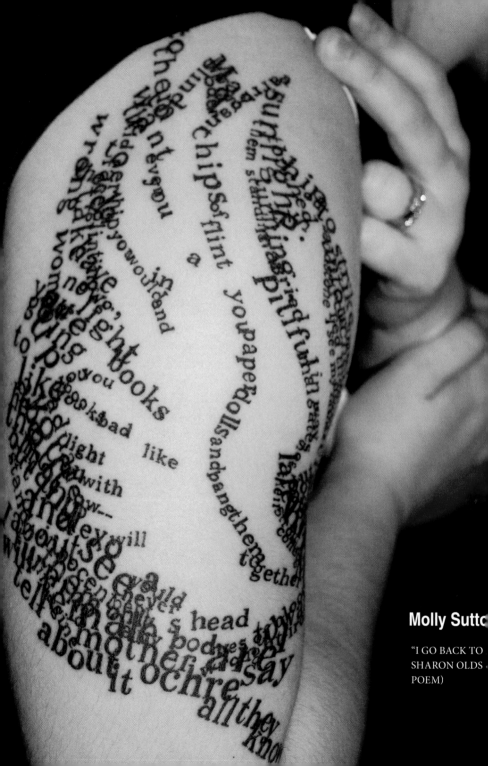

Molly Sutt

"I GO BACK TO
SHARON OLDS
POEM)

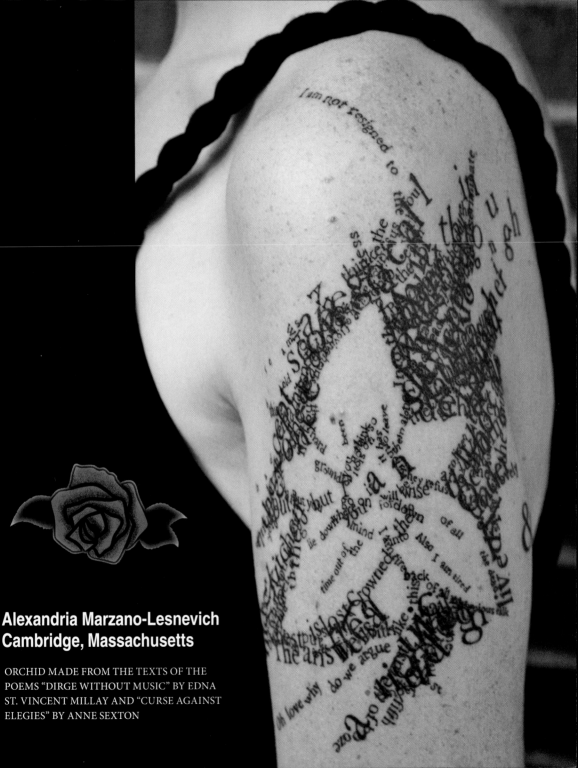

Alexandria Marzano-Lesnevich
Cambridge, Massachusetts

ORCHID MADE FROM THE TEXTS OF THE
POEMS "DIRGE WITHOUT MUSIC" BY EDNA
ST. VINCENT MILLAY AND "CURSE AGAINST
ELEGIES" BY ANNE SEXTON

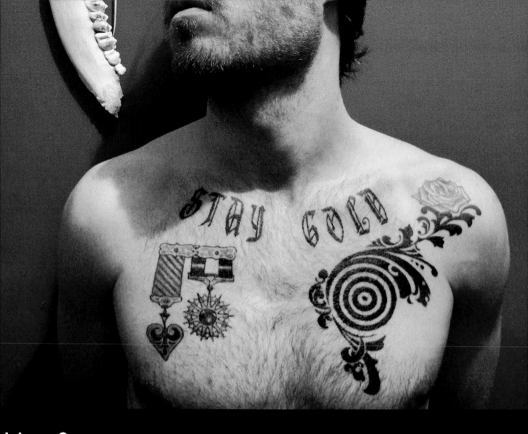

Johnny O.
Brooklyn, New York

Johnny O.
Brooklyn, New York

"STAY GOLD"

Referencing both the 1967 novel *The Outsiders* and Robert Frost's poem "Nothing Gold Can Stay," this text tattoo represents a personal paradox for me. After the death of my father in 2005, a lot of my tattoos have paid homage to his strength in contradiction—he was both a solid Army Ranger and an expressive writer. For me, "Stay Gold" articulates a way of living in a state of constant wonderment alongside the continuous reminder of death. Gold, the purest of the metals, is always beautiful, always true, and as Ponyboy, Frost and my father believed, that amongst all this horror, one can still find and live in the spots of gold—and gold never dies.

The Perks of Being a Wallflower, by Stephen Chbosky, is one of the few books I've read dozens of times since I first purchased it at fifteen and haven't gotten sick of. It's probably my favorite book. I chose that quote because I really feel that it is possible to feel never-ending, especially when you're somewhere you truly belong.

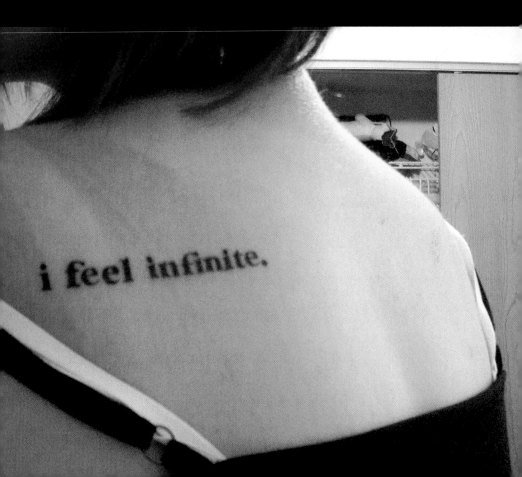

Maria Young
Wilmington, North Carolina

LINE FROM *FIGHT CLUB* BY CHUCK PALAHNIUK

My tattoo is a quote from the book *Fight Club* by Chuck Palahniuk. To me, it signifies the person that I was able to become after a long (well, not too long, but five and a half years when you're only twenty-four, right?), hard marriage, and the subsequent divorce. I am a better person now, and I truly believe it's because I went through hell.

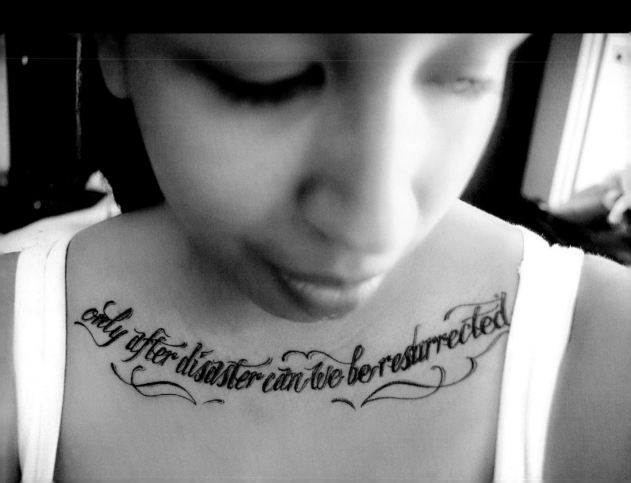

Justin Haas
Gainesville, Florida

"GEORGE ORWELL GOT IT BACKWARD" AND "BEAT"

The top quote is from Chuck Palahniuk's novel *Lullaby*: "Old George Orwell got it backward. Big Brother isn't watching. He's singing and dancing. He's pulling rabbits out of a hat. Big Brother's holding your attention every moment you're awake. He's making sure you're always distracted. He's making sure you're fully absorbed. . . . With the world always filling you, no one has to worry about what's in your mind. With everyone's imagination atrophied, no one will ever be a threat to the world."

It's tattooed on me backward, in a hard-to-read font. I'd be sort of a hypocrite if I were to broadcast the words of the quote everywhere.

The other tattoo is "beat," for Jack Kerouac and the beatnik writers. I got that tattoo when I was twenty-two or so. I'd fallen on hard times, and the beat literature really spoke to me. I felt as if those writers were in the same situation: lost, disillusioned, drunk. The word "beat" applied to me on several levels. I was engrossed in the Beat literature. I felt beat down by the world. I was a punk-rock drummer.

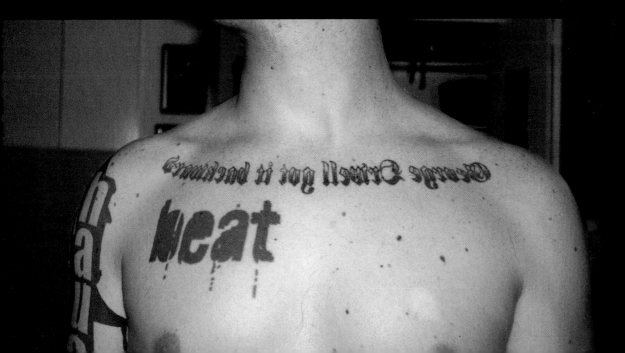

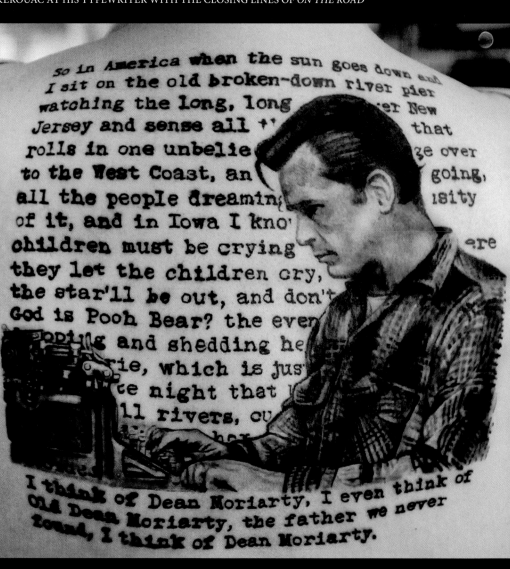

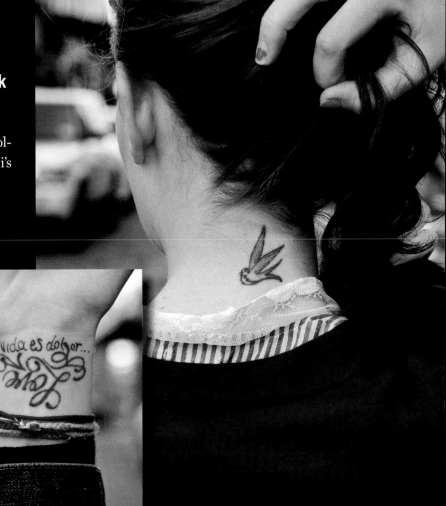

Caitlin Colford
New York, New York

BUKOWSKI BLUEBIRD

The bluebird symbol-
izes Charles Bukowski's
"Bluebird" poem.

Caitlin Colford
New York, New York

"LA VIDA ES DOLOR"

This is in honor of the quote from Jack Kerouac's *Tristessa*—"I said *la vida es dolor* (life is pain), she agrees, she says life is love too."

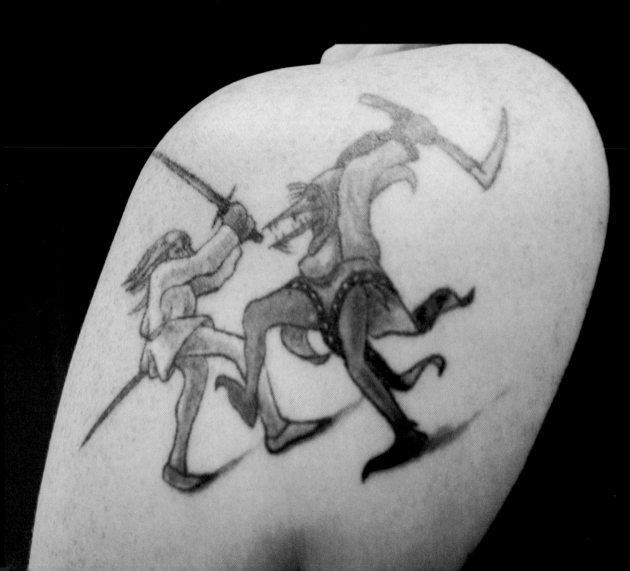

Florence Ivy
Mastic Beach, New York

ILLUSTRATION FROM STEPHEN KING'S *THE STAND*

Lindsay Keller and Melysa Cassidy
San Francisco, California, and New York, New York

MATCHING CITY LIGHTS LOGOS

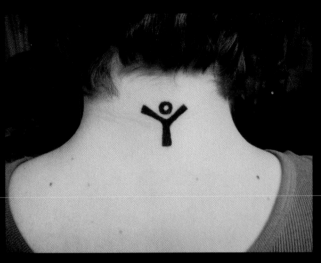

We are sisters, writers, and book-worms—both simultaneously in love with and terrified of our writing. We own more books than we do family photos. But we didn't grow up together. We are nine years, seven months, and eighteen days apart. We didn't really know each other until 2000, when our mother died and we moved in together. We didn't know how to be sisters, how to start a relationship we both longed for. But we found out how to through literature. Our relationship grew out of literature and both of us were highly influenced by the history and writing that came out of City Lights.

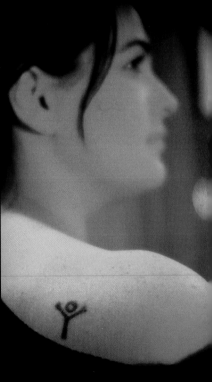

The Beat poets reached us both at the same age, years apart. Ferlinghetti was our first love, followed by Ginsberg, followed by Prévert. All were pocket-sized books with the symbol of City Lights Publishers stamped on the inside cover and on the spine. To tattoo this symbol onto us was to make a promise to ourselves as writers and to each other as sisters to be strong, keep writing no matter what, and never let each other go. I was eighteen and Melysa was twenty-eight, and the logo was the first tattoo for both of us. I live in California now and she lives in New York City, but we always have a little reminder of each other with us.

159

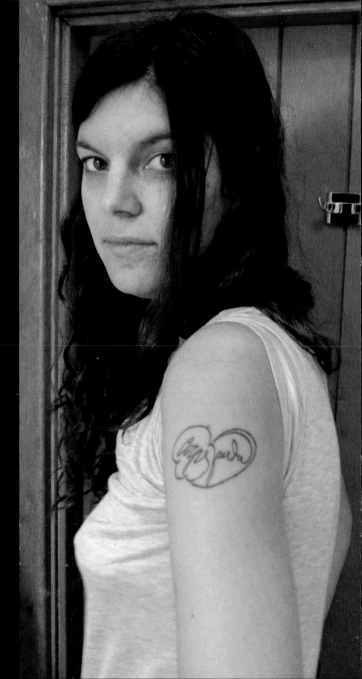

Amy McDaniel
Atlanta, Georgia

CORPS PERDU

The image is the drawn title of a book of poems called *Corps perdu* by Aimé Césaire. Pablo Picasso illustrated the book and drew the title thus. The title is translated from the French as "lost body," which is literal (*corps* = body, *perdu* = lost), but the expression "*à corps perdu*" is used to mean in the moment, unmitigatedly, lavishly, recklessly. This takes a lot of explaining, which I foolishly did not anticipate. I read the book after I already had the tattoo, and I didn't know the less-literal translation until after the fact, but these meanings seem appropriate now. I chose it because I like Picasso, words, and the French language. People have read it as carpe diem, cozy peach, or someone's name in a heart. It is none of these. It is all of these.

...ng *Moby Dick* for a long time. I was sure it was going to be terrible.
...ke American Romanticism in order to finish my degree, and *Moby-*
...f that course. Knowing I'd never be able to finish the book during the
...arted early in the summer. It took me months—I didn't finish until
...e more I read, the more I fell in love with the book. Man's struggle to
... accept God rests at the core of Melville's book, and this resonated
...No matter how many ways I try to explain and rationalize God, no
...ch I try to study and understand God, I am left staring at the myste-
...owable, the Infinite. I can perceive God as a loving father, I can deny
...can rage against an indifferent being, or I can simply be in awe of
...doesn't matter, because all of these views are only fragments of the
...end, I know him not, and never will.

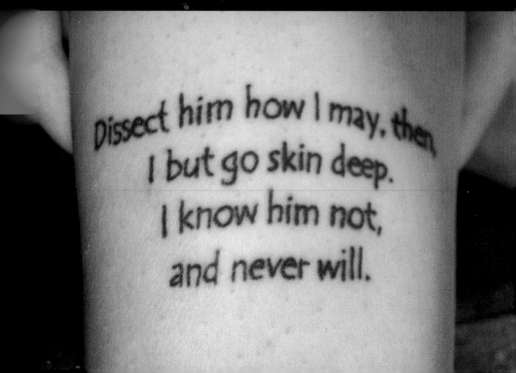

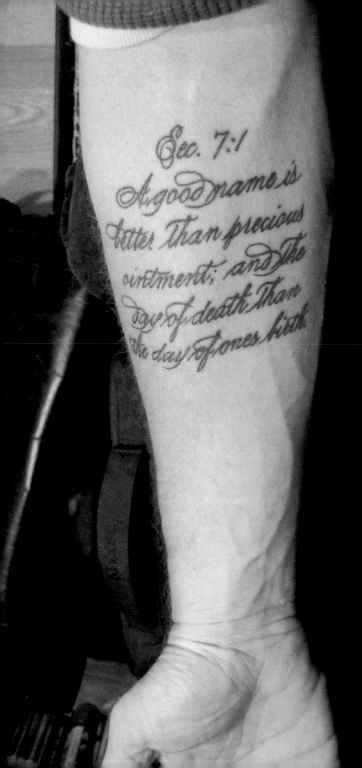

Chris Heavener
New York, New York

ECCLESIASTES 7:1

This is a Bible verse my grand-mother used to quote often. I got it after she passed away a couple years ago. It says, "A good name is better than precious ointment; and the day of death than the day of one's birth." I'm not particularly religious. She was, though, to a serious degree. I like the message: have a good name, a good reputa-tion. I'm pretty sure the second half of the verse is a reference to dying and going to heaven, the existence of which I haven't really made my mind up on just yet. Also there's a semicolon in there, which I'm not too happy about, but I wanted to be faithful to the material.

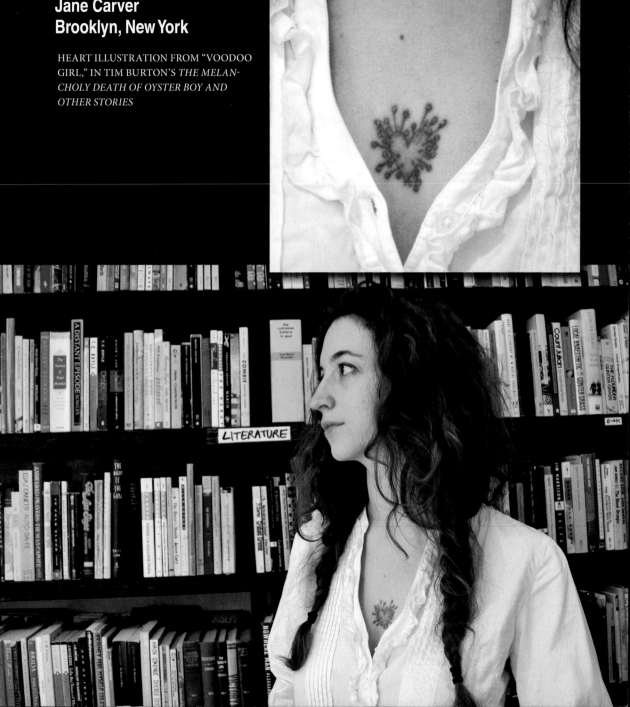

Jane Carver
Brooklyn, New York

HEART ILLUSTRATION FROM "VOODOO
GIRL," IN TIM BURTON'S *THE MELAN-
CHOLY DEATH OF OYSTER BOY AND
OTHER STORIES*

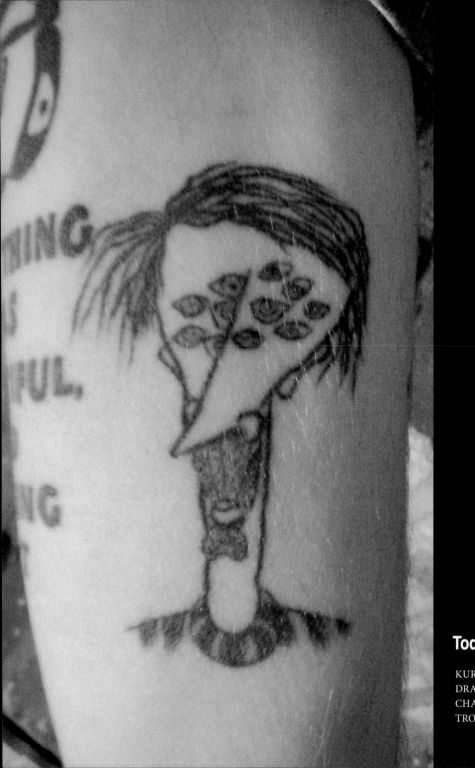

Todd Kurpel

KURT VONNEGUT
DRAWING OF HIS
CHARACTER, KILGORE
TROUT

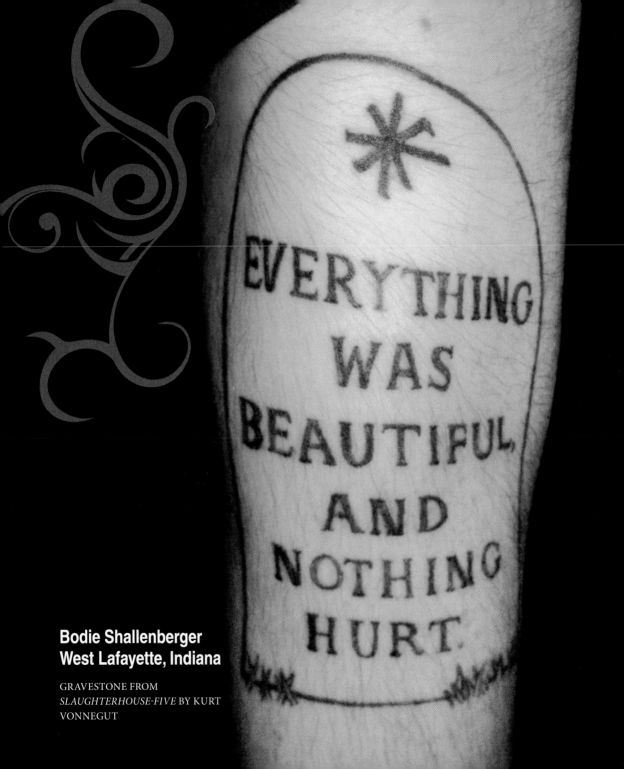

**Bodie Shallenberger
West Lafayette, Indiana**

GRAVESTONE FROM
SLAUGHTERHOUSE-FIVE BY KURT
VONNEGUT

Acknowledgments

To all of our contributors: Thank you for sharing your ink and your words; for persevering through any and all technical difficulties; for inviting us into your homes, places of business, and lives. Thanks as well to Jean Adamoski, Mehai Bakaty, Jill Ciment, Frederick Barthelme, Katharine Barthelme, Brandi Bowles, Shelley Jackson, Gene Morgan and everyone at HTMLGIANT.com, Tony Perez, Andy Riverbed, Michael Signorelli, and the whole Harper Perennial team.

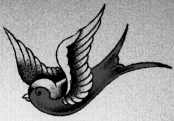

Tattoo and Photographic Credits

Portrait of John Berryman (page 1): Nate Abney at Designs by Dana, Cincinnati, Ohio

"Poem" (page 3): © Mathias Svalina

Line from "The Walking" (page 4): John Schuettler at First Place Tattoos, Hackettstown, New Jersey

Stanza from "Night" (page 5): Bleach at Saint Sabrina's, Minneapolis, Minnesota

William Clifford (page 7–12): © Christine Arbulu

Line from "Myth of Sisyphus" (page 13): Virginia at New York Adorned, New York, New York

Kristina Grinovich (pages 16–19): Brian Hemming at Regeneration Tattoo in Allston, Massachusetts

Lines from *A Season in Hell* (page 20): Tala at Black and Blue Tattoo, San Francisco, California

Lines from "East Coker" (page 21): Zac Black of Victory Tattoo, Chico, California

"Yes I said / Yes I will Yes" (pages 24–25): Kadillac Tattoo, Manayunk, Pennsylvania

"See Hear Feel" (page 26): Chantal Smith at Venus Modern Body Arts, New York, New York

"Ever tried . . . / Ever Failed . . ." (page 27): Billy Barnett at Tattoo 454 in Leucadia, California

"Hold to the now . . ." (page 28): Tim Jordan at Optic Nerve in Portland, Oregon

Last line of *The Unnamable* (page 29): © Method 606

Katharine Barthelme "Born Dancin'" (page 33): © Thomas Blake Ling

Sleeve depicting scenes from *Infinite Jest* (page 36): Jason Louiselle / © Holly Metz

Opening lines of *Gravity's Rainbow* (page 38): Derrek at Broken Art Tattoo, Silverlake, California

Title of *V* (page 39): Andre at House of Tattoo, Tacoma, Washington

Scenes from *Don Quixote* (page 40–41): VanCort Richards at Slave to the Needle, Seattle, Washignton

Fragment from *Ignorance* (page 43): Studio City Tattoo, Los Angeles, California

"SKIN" Shelley Jackson (page 45): © Justin Taylor

"Here" Rick Moody (page 49): © Justin Taylor

"We" Alexis Turner (page 50): © David Geoffrey Robinson

"hard" Liz Coffey (page 51): © Siobhan Creedon at Darkwave Tattoo, Roxbury, Massachusetts

"of" and "Law" Emily Hall and Phil Campbell (page 53): © Eva Talmadge

Line from *Brideshead Revisited* (page 56): Logan Aguilar at Venus Modern Body Arts, New York, New York

Illustration from *Salomé* (page 58): Javier Punk

Opening line of *Notes from the Underground* (page 62): Brian Hemming at Pino Bros., Ink, Cambridge, Masschusetts

"How do you like your blue-eyed boy, Mr. Death?" (page 64): Ol Dirty Rob at Anthem Tattoos, Gainesville, Florida

Robert Lee Emigh III (page 71–72): Trish at Enchanted Ink, Boulder, Colorado (for the Evenson); Phil Bartell at Rising Tide Tattoo, Boulder, Colorado (for the half-sleeve)

Jabberwocky (page 74): Dan Eternal at Eternal Body Art, Honolulu, Hawaii/ © Cynthia McCoy

Scene from *The Runaway Bunny* (page 75): Jamie Hale at Aces High, West Palm Beach, Florida

Illustrations from *Where the Wild Things Are* (page 76): Heide Unger at Millennium Gallery of Living Art, Fort Collins, Colorado

Illustration from *Harriet the Spy* (page 78): Dan Morgan at Pirate's Alley Studio Olds, Alberta, Canada

Illustration from *Hector the Collector* (page 79): Adam Patterson at Jersey City Tattoo Co, Jersey City, New Jersey

Anonymous at AWP (page 85): © Justin Taylor

"Live Forever" (page 86): Vanessa Waites at Underground Art in Memphis, Tennessee / © Joey Miller

Line from *The Sandman* (page 87): Rockabilly Chris

UBIK (page 88–89): © Justin Taylor

Comics Code Authority (page 91): Living Art Studio, Northampton, Massachusetts

Ignatz Mouse (page 93): Ross Kennedy/©Bill Hayward

"Read or Die" (page 94): © Justin Taylor

Passages from *Neuromancer* (page 98): Nigel Palmer at Nine

Twilight covers (pages 100–101): Maria Tolo at Fjord Tattoo

"HP is the best hope we have . . ." (page 102): Pirata Tattoo Studio, Cachoeirinha, RS

Illustration from *The Tales of Beedle the Bard* (page 103): Cassie Stover at Hudson Tattoos, Oklahoma City, Oklahoma

Peter Pan Thimble and Harry Potter "Patronus" (page 103): Sacred Heart Tattoo and Piercing, Houston, Texas

Last line of *Bartleby, the Scrivener* . . . (page 106): Anthony Anderson at Lost Art Tattoo, Salt Lake City, Utah

Rockwell Kent illustration from *Moby-Dick* (page 108): © Justin Taylor

Caricature of Mark Twain (page 109): © Justin Taylor

Portrait of young Walt Whitman (page 110): Eric Edward at Trueblue, Middle Village, Queens

Portrait of old Walt Whitman (page 111): © Justin Taylor

Alphabet (page 116): Mike at Bleeding Heart, Lee's Summit, Missouri

Alphabets in upper and lower cases (page 117): © Justin Taylor

Dewey decimal number for poetry (page 118): Metamorphosis Tattoo & Piercing, Indianapolis, Indiana

Librarian and skull (page 119): Ron Hendon at Midnight Iguana Tattooing, Athens, Georgia

"Book Lust" (page 120): Jean Chen at Lighthouse Tattoo, San Francisco, California

"Interrobang" (page 121): © Justin Taylor

Art from *The Collected Stories of Flannery O'Connor* (page 124): Doug Hollis at Oxford Tattoo Company

"What's outside the window?" (page 125): Jesse Crowley at Ancient Arts Tattoo Studio.

Lines from "Godzilla in Mexico" (page 126): Elio Espana at Fly Rite Studio, Brooklyn, New York/© Justin Taylor

Fragment from *The Sound and the Fury* (page 127): Mehai Bataky at Fineline Tattoo, New York, New York/© Linette McCown

Fragment from *To the Lighthouse* (page 128): Sean at Chameleon Tattoo and Body Piercing, Cambridge Masschusetts

Haiku (page 132): Jorge of Himiko in Kyoto Tattoo

Illustrations from "The Cap and Bells" (page 138): Gabriel "Big Gabe" Bayles at Scorpion Studios, Houston, Texas

"Quod amo me delete" (page 141): Adam Kogut at In One-Tattoo Studio

Line from *Aeneid* (page 142): Wild Zero Studios, Morgantown, West Virginia/© Lauren Lamb

"Some of my favorite authors" (page 143): © Eva Talmadge

Tree of life (page 145): Cat at the Pain Station, St. Louis, Missouri

Excerpts from "Dogfish" (page 148): Mandie at Vintage Tattoo Parlor, Los Angeles, California

"I go back to May 1937" (page 150): © Jan Sutton

Orchid (page 151): Ram at Fat Ram's Pumpkin Tattoo, Jamaica Plain, Massachusetts

"Stay Gold" (page 152): Logan at Asylum Tattoo Brooklyn, New York/©Justin King

Line from *Fight Club* (page 154): Ryan Flaherty at Insight Tattoo Studios in Chicago, Illinois

Kerouac at his typewriter (page 156): Thor at Yonge Street Tattoos, Toronto, Canada

Bukowski bluebird and "*La vida es dolor*" (page 157): © Leslie Hassler

Corps Perdu (page 160): Mark at Sacred Heart, Atlanta, Georgia/© Sara Faye Lieber

Heart illustration (page 163): Lars Johannson at Viking Studios, Columbus, Ohio/© Justin Taylor

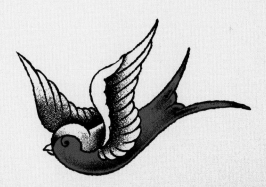

MORE FROM JUSTIN TAYLOR

EVERYTHING HERE IS
THE BEST THING EVER

ISBN 978-0-06-188181-7 (paperback)

"Justin Taylor is a master of the modern snapshot."
—*Los Angeles Times*

"Superb . . . Each story is spare and clean and
speaks the truth in beautiful resonant prose"
—*Publishers Weekly*

THE GOSPEL OF ANARCHY

ISBN 978-0-06-188182-4 (paperback)
COMING FEBRUARY 2011!

With wit, warmth, and remarkable insight, Taylor
tracks the disillusionments and epiphanies of
young punks living on the outskirts of Gainesville,
Florida. *The Gospel of Anarchy* reaffirms Taylor as
one of America's most talented young writers.